THE
BROCKTON TRAGEDY

AT

MOOSEHEAD LAKE

THE
BROCKTON TRAGEDY
AT
MOOSEHEAD LAKE

JAMES E. BENSON AND
NICOLE B. CASPER

FOREWORD BY COLONEL JOEL T. WILKINSON,
MAINE WARDEN SERVICE

THE
History
PRESS

Published by The History Press
Charleston, SC
www.historypress.com

First published 2018

ISBN 9781540233509

Library of Congress Control Number: 2017963914

Notice: The information in this book is true and complete to the best of our knowledge. It is offered without guarantee on the part of the authors or The History Press. The authors and The History Press disclaim all liability in connection with the use of this book.

This book is dedicated to the ten men lost on Moosehead Lake on May 13, 1928; the lone survivor; their families; and all of those who worked tirelessly to bring this tragedy to a close.

CONTENTS

FOREWORD

This book captures and provides you with a factual account of a tragedy that affected the families and communities of two regions of New England distinctly different but connected by the bond of the human spirit and a love for such a special place in Maine. Having lived, worked and patrolled the very waters this tragedy occurred on, I am reminded of the spiritual connection to all who visit, live, work or recreate within the Moosehead Lake region. Its size and ability to change in a moment's notice have resulted in many recoveries and search-and-rescue missions for the Maine Warden Service throughout the agency's nearly 138 years of formal existence. To my knowledge, none reached the size of this effort. Although a tragic event, it demonstrates the strength of community and the value and care placed by locals, responders, businessmen and politicians in the importance of bringing all those who perished home to their families and communities. It returns you to an era where true kindness, good will and respect for fellow man played out through the actions of all. As you read this, you will be in awe of the sheer size and mass of such a beautiful location but will also be reminded of the forces of nature, as mankind does its best to balance the enjoyment of this unique place against the dangers it can and will continue to present for all those who venture to it.

COLONEL JOEL T. WILKINSON,
Maine Warden Service

ACKNOWLEDGEMENTS

The success of projects like this is the result of support and assistance from a variety of people and institutions. The Brockton Historical Society and Fire Museum, Brockton Public Library, Moosehead Historical Society, Moosehead Marine Museum, Bowdoin College Archives, Portland Public Library (Maine), Brockton City Clerk's and Greenville Town Clerk's Offices, as well as First Evangelical Lutheran Church in Brockton, all provided a wealth of resources in the research of this book, and for that we are appreciative. In particular, we would like to thank Jane Swiszcz, reference librarian at the Stonehill College Library, and Anne Fleming, reference librarian at the Brockton Public Library, for their assistance in tracking down government records.

We would also like to thank the following individuals who assisted us in obtaining images or providing accounts of the victims and tragedy: Elizabeth Lays, Roger Lays, Nancy Lays McPherson, Virginia Lays, Todd von Hoffman, Paige von Hoffman, Eric Sandberg, Lynne Sandberg Boudoucies, Chief Kenneth Galligan (Brockton Fire Department retired), Deputy Chief Kevin Galligan (Brockton Fire Department), Rocky Lizzotte (town clerk of Greenville, Maine), Joseph MacDonald (Plymouth County sheriff), John Birtwell (director of public information and office technology, Plymouth County Sheriff's Office), John Murphy, Lloyd F. Thompson, Colonel Joel T. Wilkinson and Denise M. Brann of the Maine Warden Service.

ACKNOWLEDGEMENTS

A special expression of gratitude is given to Stonehill College students Angela Farias ('18), Jennifer DiPersio ('18) and Julia Turgeon ('18) for their assistance with scanning and editing photos for possible inclusion in this book. A huge debt of gratitude is also owed to Jonathan Green, assistant director and digital assets manager of the Stonehill College Archives, for his support and countless hours of proofing and editing this manuscript. A word of thanks is also due to Cheryl McGrath, director of the Stonehill College Libraries, for her support of this project.

A special thank-you goes to Michael Kinsella, Ryan Finn and the staff of The History Press for making this book possible. Their professionalism is above reproach and greatly appreciated.

Lastly, no book such as this would have been possible without the support of our families and friends. Nicole would like to thank her husband, Michael J. Casper; parents, Dean and Diane Tourangeau; and in-laws, James and Marianne Casper, for their excitement, patience and support during the writing of this book. She would also like to thank her family and friends for their ongoing support and encouragement. James would like to thank his father, S. Erick Benson, and all of his family and friends for their continued support during the time that this book was in the process of being researched and written.

INTRODUCTION

An integral part of the word *history* is "story." While stories are often fiction, history is a story of facts about certain events that should be remembered. The drowning of these nine Brocktonians and their Maine guide was not the first nor the last at Moosehead Lake. It is, however, believed to be the largest loss of life on the lake at one time. Why, then, have so few heard about it? Is it because the tragedy occurred two hundred miles from the home of most of these men? Does the lack of a visible reminder, like a burned building or memorial, detract from the widespread knowledge of the event? Or is it because tragedies such as these happen every day, and once the initial shock passes, the media moves on to the next story and those not directly affected return to their daily lives? Did the Great Depression, Brockton's Strand Theatre Fire and World War II overshadow the event, causing it to fade from historical memory?

This book does not attempt to answer those questions. Rather, this volume tells the story of the drowning—the first account of the tragedy gathered in a single work. Who were David Bridgwood, Knute Salander, William Daley, John Sandberg, Earl Blake, Arthur S. Peterson, Frank Moberg, Harry Howard, G. Fred Dahlborg, James Lays and Samuel Budden? What caused the boat to sink, and why did only one of eleven survive? It is a story of remembrance, preserving the memory of those taken too soon from a city and town they loved.

CHAPTER 1

PROLOGUE

Newspaper headlines during the first months of 1928 were rather mundane, as the world was, at least from all appearances, at peace. Nevertheless, the pot boiled beneath the surface in many areas. In the Soviet Union, Leon Trotsky was exiled as Joseph Stalin came to power, while Norway elected Christopher Hornsrud as prime minister at the age of 101. In April, a plot to assassinate Italian monarch Victor Emmanuel and Italian Premier Benito Mussolini was uncovered in Italy. In the United States, President Calvin Coolidge announced that he would not be a candidate for reelection in November. Technology also made headlines when the first air-conditioned office building in the United States opened in San Antonio, Texas, on January 1, 1928. At the end of January, the 3-M Company introduced "Scotch tape" to the world, while the first transatlantic television image was received in Hartsdale, New York. Aviation was also all the rage after Charles Lindbergh's solo transatlantic flight, a year earlier in May 1927, made flight and the conquest of the skies the object of many men and women worldwide. In March, World War I ace Captain Walter G.R. Hinchliffe of England piloted a flight on which British actress Elsie Mackay, also known as Poppy Wyndham, was the passenger on a quest to fulfill her desire of being the first woman to cross the Atlantic by plane. Shrouded in secrecy—lest Mackay's father, James Mackay, who was chairman of the great shipping company Peninsular and Oriental Steam Navigation Company (P&O) find out her intentions—the duo left Lincolnshire, England, at 8:35 a.m. on March 13 bound for New York. The plane was sighted twice that day and never heard from again. Mackay's goal of being the first woman

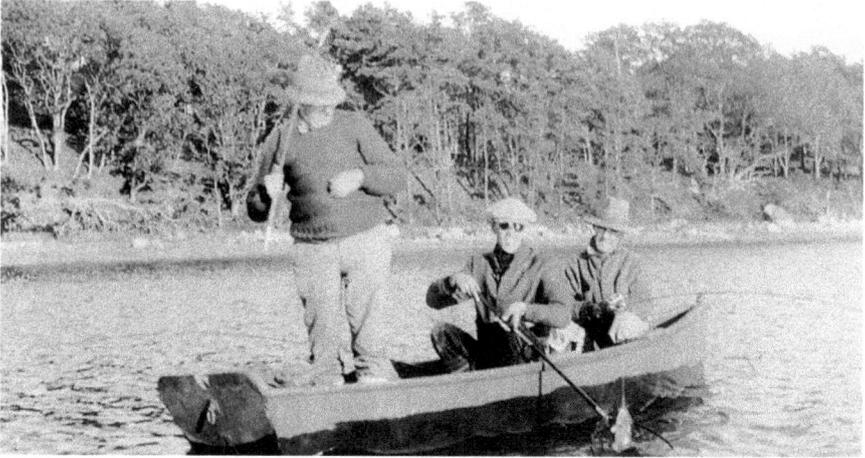

John Sandberg on previous fishing trip with unidentified friends, no date. *Courtesy the Sandberg family.*

to cross the Atlantic was achieved a few months later when Amelia Earhart flew as a passenger in an aircraft piloted by Wilmer Stultz. In Massachusetts, the Barnstable Chamber of Commerce, in an effort to deal with growing traffic congestion, recommended that new bridges or tunnels be constructed across the Cape Cod Canal. With a busy, bustling world around them and at home, ten men, good friends with a longing to spend time away from their professional duties, eagerly awaited their long-planned trip to fish the waters of Maine's famed Moosehead Lake.

BROCKTON, MASSACHUSETTS

The Roaring Twenties were in full swing, Prohibition was in its ninth year and the economy was strong. One place enjoying the prosperity of the day was the city of Brockton, Massachusetts, located about twenty-five miles south of Boston. Brockton was a progressive city, the center of commerce and industry for much of southeastern Massachusetts—a city of firsts. In October 1883, it became the first city in the world to have a three-wire underground electrical system designed by Thomas Edison. A year later, the City Theatre became the first in the world tied into a three-wire system, and a year after that, Brockton's Central Fire Station became the first electrically operated fire station in the United States. For the bustling city

with three railroad stations, large freight yards and an enormous amount of train traffic, all railroad grade crossings were abolished in 1896, making it the first city in the country to do so, increasing the safety of citizens and reducing congestion.[1]

Brockton was one of the world's largest industrial centers for the production of men's and boys' boots and shoes, with scores of manufacturers turning out quality products. Among them, two of the world's largest footwear manufacturers of the day, were the George E. Keith Company and the W.L. Douglas Company. With the founders of both companies recently deceased, the companies began to change manufacturing philosophies with respect to geographical consolidations and expanded product offerings. In March 1928, the Keith Company moved its sole leather department from Boston to Brockton, bringing the city upward of 150 new jobs.[2] A few weeks later, the company announced that it would move its manufacturing of shoes with wooden heels from Boston to Brockton, creating an additional 50 to 60 jobs.[3]

Meanwhile, in April that year, the W.L. Douglas Company announced that it would begin to manufacture a new woman's shoe using the Littleway process, which had been developed in Lynn, Massachusetts. This process—which resulted in the production of a tackless, light and flexible shoe—had never been used in the Brockton shoe factories. The Douglas Company predicted that it would be able to produce up to 1,000 pairs per day and an average of 200,000 per year.[4] On May 8, the George E. Keith Company reported that it would begin to manufacture women's shoes in Brockton, an announcement that led the *Brockton Times*, a newspaper founded by rival manufacturer William L. Douglas, to declare that this was a "move thought to be the beginning of Brockton as the Shoe Center of the World."[5]

As Brockton's economy boomed, so did its population. In 1649, English settlers purchased the area encompassing Brockton from Massasoit, sachem of the Wampanoag tribe. Organized in 1656 as part Old Bridgewater, the area that is now Brockton was known as North Parish. In 1822, North Parish became the town of North Bridgewater. In 1874, North Bridgewater took the name Brockton and, in 1881, became a city. In 1830, the town's population was 1,953; by 1880, Brockton had a population of 13,608. The city's population doubled in size to 27,294 by the 1890 census. By 1910, it once again doubled in size to 56,878 and, in 1920, reached a total population of 66,254. This growth, due largely to the shoe industry and its ancillary businesses, was aided by a large influx of immigrants from Sweden, Ireland, Lithuania, Italy and other countries. These immigrants worked in the more than ninety shoe factories the city was home to in about 1900, factories

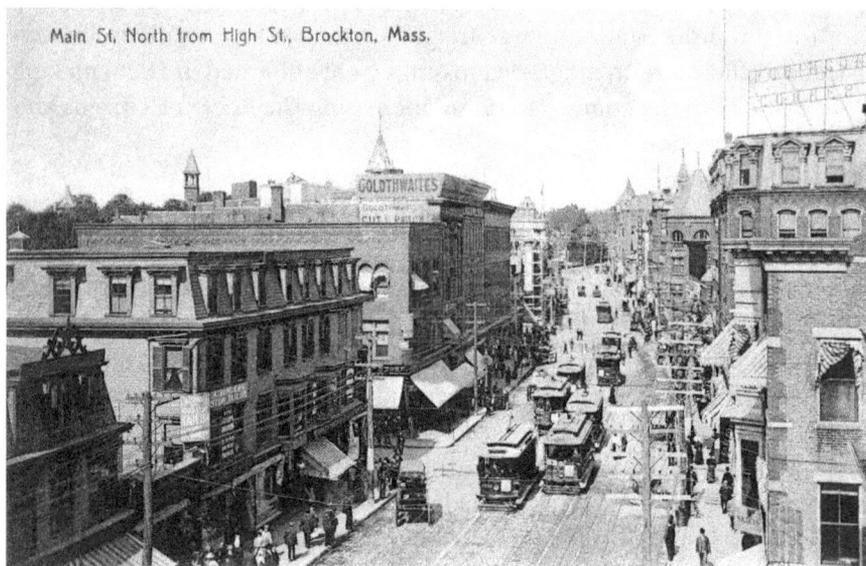

Main St, North from High St, Brockton, Mass.

View of Main Street, Brockton, Massachusetts, looking north, circa 1930. *Collection of author James E. Benson.*

that employed more than 13,000 workers. Those immigrants not working in the shoe industry worked for (and, in many cases, owned) other businesses such as markets, bakeries and machine shops. Immigrants also worked in the trades or went on to higher education, becoming doctors, lawyers and teachers.

In 1928, Brockton had a total proposed city budget of $3,222,139.17.[6] News that spring included Edgar's department store celebrating its fiftieth anniversary by giving away in a contest seven new Ford automobiles. Local newspapers advertised a two-door Pontiac Six for $745, while a Studebaker Commander went for $1,495.[7] The Brockton Edison Company advertised a new electric kitchen gadget, an electric egg beater/mixer, for $8.33. At the Brockton Public Market, bananas were $0.19 per dozen, and lobster sold for $0.35 per pound. *Love*, starring Greta Garbo and John Gilbert, played at the Strand Theatre, while the Rialto Theatre featured *The Circus*, starring Charlie Chaplin. Brockton's chief executive, Mayor Harold Bent, made headlines when he mailed a quart of Plymouth Rock brand ice cream to Manchester, New Hampshire Mayor Arthur Moreau using the newly developed "dry ice."[8] The total cost to ship was $0.55—the dry ice cost $0.30, while the special handling mailing was a quarter. The Roaring Twenties had Brockton roaring and on the move.

Greenville, Maine

About two hundred air miles northeast of Brockton sits Greenville, Maine, on the southern shores of Moosehead Lake, gateway to Maine's great north woods. Before 1820, while Maine was still a part of Massachusetts (Maine became a state in 1820), the area now encompassing the southern portion of Greenville was known as T9 R10 NWP (Township 9 Range 10 North of the Waldo Patent) and was granted by the Great and General Court of Massachusetts to Thornton Academy of Saco (Maine) in 1812. These land grants were generally meant to serve the institutions to which they were granted as an endowment, with the income realized mainly through the harvesting and sale of timber. In 1824, the academy sold this land to Thomas Haskell of Westbrook, Maine. Nearby, Wilson Stream provided water flow suitable for the placement of a sawmill as well as a gristmill, and the land around Wilson Pond was suitable for farming. Haskell, aided by Oliver Young and John Smith, cleared the land, and in 1827, Haskell moved his family into their newly constructed house. In 1831, the location was named Haskell Plantation.[9]

As time moved on, more and more settlers arrived in the area. Several of these pioneers erected sawmills on local waterways in addition to Wilson Stream. Mills appeared on Eagle Stream and Bog Stream to process the trees felled to clear the land and produce lumber for the building of the town's structures. One such pioneer was Henry Gower, who arrived in 1835 and cleared a parcel of land that would become Greenville Village. Gower later erected the settlement's first public house, the Seboomook, and a store. On February 6, 1836, Haskell Plantation was incorporated as Greenville, a name paying homage to the lush forests in which it was nestled.[10] The noted poet, author and diplomat of the mid-nineteenth century James Russell Lowell, after his visit in 1853, described Greenville in his book *A Moosehead Journal* as "a little village which looks as if it had dripped down from the hills, and settled in the hollow at the foot of the lake." Captain Charles Alden Farrar, an author of several travel guides on Maine, wrote this description of Greenville in 1889:

> *This little town nestles cozily the foot of the lake, which is here very narrow, and is thickly studded with rocky islands covered with a growth of fir and spruce, presenting from the eminence…the appearance of a beautiful archipelago. There are now two distinct settlements, that at East Cove* [Greenville] *being the oldest. The advent of the railroad gave birth to*

the village of West Cove [Greenville Junction], *and it is fast growing.
The distance between the two villages…is a mile and a quarter….There
is a considerable trade carried on…the entire year in furnishing supplies to
the visiting sportsmen in summer, and to the lumbermen in winter, many of
whom congregate here every fall and spring on their way to and from the
numerous logging camps around and beyond the lake.*[11]

Lumbering in the north woods was in its infancy in the 1830s, but the area
around Moosehead Lake was the ideal location to grow this industry. The
enormity of the lake provided a way to move great amounts of timber across
the waterway. As early as 1836, a man by the name of Cole had a small
steamboat on the lake for towing logs. A few years later, a larger steamboat
was added, and over the years, many more would follow to work the logs
down the lake and to shuttle passengers to various parts of the lake. In 1846,
a second boardinghouse, the Eveleth House, was built. The town in the
wilderness was growing. The federal census of 1840 showed a population
of 128, which included scattered residents from other small settlements to
the north. Within ten years, the population had grown by more than 150
percent, reaching 326 by 1850. Greenville's population grew by double
digits each year, reaching a population of 1,550 in 1920 and hitting its
peak in 1960, when it recorded 2,025 residents. As of the 2010 census, the
town had only 100 more residents than it did in 1920. However, throughout
all its history, the town's transient population has gone up and down, as
lumbermen, fishermen, hunters and tourists all traveled to and from the
great north woods. Today, only one steamboat remains on Moosehead Lake,
the *Katahdin*, which has plied the Moosehead waters since 1914.

Logging would for many years be the economic force giving Greenville
its vitality. Many of Maine's lumber barons made vast fortunes in the area.
Among them was Milton G. Shaw, who at one time owned more than 1
million acres of prime timberland in the region. Adding to Greenville's
vitality was the coming of the railroad. The railroads brought men to and
from Greenville to work in the logging camps, tourists and "sports" to relax
and recreate, as well as millions of board feet of lumber shipped to the mills.
The Bangor & Piscataquis Railroad, later the Bangor & Aroostook, came to
neighboring Greenville Junction in the middle of 1884, and four years later,
the International Railway of Maine, constructed by the Canadian Pacific
Railway, laid its tracks through town. The Somerset Railroad, which served
the communities of the Kennebec River Valley as far north as Bingham,
expanded the line in 1906 to Rockwood, and in 1911, it was purchased

View of Greenville, Maine, circa 1920s. *Collection of author James E. Benson.*

by the Maine Central Railroad, along with the Mount Kineo House, and renamed the Kineo Branch, servicing the grand resort until the line was shut down in September 1933.

In 1928, Greenville's town budget was $52,530.33, of which nearly half went to education. The town report for that year shows that $30 was paid in bounties on porcupines and $771.17 for street lighting. Also in that year, the town built a vault at the cemetery with an access road at a cost of $1,633.33.[12] In 1928, Greenville had a Great Atlantic & Pacific Tea Company grocery store, several general stores and a pharmacy. The town had one boat builder, J. Fred Sawyer, and one undertaker, Orville C. Harvey, as well as two medical doctors and one hospital. The president of the Hollingsworth & Whitney Logging Company, Charles Augustus Dean of Wellesley, Massachusetts, established the Charles Dean Hospital. Greenville was small but operated much like the bigger municipalities of the day.

MOOSEHEAD LAKE

Situated on Greenville's front steps is the vast expanse of water known as Moosehead Lake. Moosehead is a virtual inland sea stretching some forty miles to the north of the village and reaching a width of up to twelve miles.

The jagged, wooded shoreline extends for more than four hundred miles. Located at an elevation of 1,023 feet above sea level in Maine's Longfellow Mountains, Moosehead is the largest mountain lake east of the Mississippi and the largest of all lakes in New England, covering about 75,471 acres. More than eighty islands (some sources indicate as many as five hundred) dot the waters of the lake with names like Moose, Deer, Dr. Wiggers, Snake, Whiskey, Spider, Farm, Mutton Chops, Squirrel and Sugar—the largest of all the islands at 5,000 acres. From the lake flow the waters that make up the 170-mile-long Kennebec River, and less than 1 mile from the outflow of the Kennebec lies the lake's inlet, Moose River. It is said that Moosehead is the only lake in the country to have its inlet and outlet not only on the same side of the lake but so close as well.[13]

Moosehead has been a destination for hundreds if not thousands of years. Early Native American tribes came to Moosehead for the highly sought-after hornstone or flint of Mount Kineo, a monolith of stone rising nearly seven hundred feet above the lake. The Red Paint People and members of the Abenaki, Penobscot and Norridgewock bands would come to Kineo to obtain its high-grade stone for making arrow points, axes and other implements of war and domestic life. Lithics (stone tools) made of Kineo flint have been unearthed as far away as New York State.

Mount Kineo is perhaps the most visible and striking feature of the lake. Because of its ties to the Native American peoples of the region, it is cloaked in stories of mystery and intrigue. Looking at Kineo from the south, the mountain resembles a large bull moose bending its head low, with its large palm-like antlers being the inlets, coves and bays of the lake and its nose making up the land around the lake. When philosopher, transcendentalist and naturalist Henry David Thoreau visited Moosehead in 1853, his guide, Tahmunt, told him that when the first white man visited the area, he saw the resemblance and called the lake Moosehead. The Abenaki people called the lake *Sebamcook* or *Sebaygook*, while the neighboring Penobscot tribe called it *Kzebem* or *X-sebem*, all roughly meaning "high bluff" and "expansive waters."[14] Some early maps call it *Cerbon*, meaning "great waters." Captain John Montresor was an engineer in the British Army Corps of Engineers in the late 1750s, and among his assignments was to survey and map the Kennebec River. On his circa 1761 map, he identified the lake with the name *Orignal*, which is the French word for moose.[15]

Also in 1853, poet, diplomat and traveler James Russell Lowell visited the region. Lowell is considered by some to be "Maine's first tourist." In his *A Moosehead Journal*, he perhaps envisioned the potential of the region to attract

visitors when he wrote, "It seemed to me that I could hear a sigh now and then from the immemorial pines, as they stood watching these campfires of the inexorable intruder."[16] Other tourists of note would follow, among them poet and abolitionist John Greenleaf Whittier and authors Mark Twain and Charles A. Stephens. As a young man, Theodore Roosevelt also visited and fished Moosehead's waters. Two perennial visitors to the area, Lucius L. Hubbard and Captain Charles Farrar, became the unofficial chamber of commerce and tourist information bureau.

Lucius Lee Hubbard was born in Ohio and educated at Harvard, graduating with a law degree. He later received advanced degrees from the University of Bonn (Germany) in science and became the Michigan state geologist from 1893 to 1899, when he went into various positions in several mining companies. Hubbard created and published many maps of areas of Maine and several tourist guides such as *Woods and Lakes of Maine, A Trip from Moosehead Lake to New Brunswick in a Birch Bark Canoe* (1884), *Summer Vacations at Moosehead Lake and Vicinity: A Practical Guide Book for Tourists* (1880) and *Hubbard's Guide to Moosehead Lake and Northern Maine* (1882).

Captain Charles Alden John Farrar was an American author and publisher of several books on Maine's north woods. Among his works are *Camp Life in the Wilderness* (1879), *Eastward, Ho!; or, Adventures at Rangeley Lakes* (1880), *Amateur and Professional Stage Life; or, The Adventures of Billy Shakespoke* (1882), *Farrar's Illustrated Guide Book to the Androscoggin Lakes* (1883), *Farrar's Illustrated Guide Book to Moosehead Lake and Vicinity* (1884), *Down the West Branch* (1886), *From Lake to Lake; or, A Trip Across Country: A Narrative of the Wilds of Maine* (1887), *The Androscoggin Lakes Illustrated* (1888), *Up the North Branch; or, A Summer's Outing* (1888) and *Through the Wilds* (1892).[17]

Hubbard and Farrar with their writings, along with Thoreau's earlier *In the Maine Woods*, gave rise to a new group of people known as "rusticators" or "sports." These people were, for the most part, civic leaders, business owners and people of some financial well-being from the industrial cities of the East. Capitalizing on the desire of people to visit the north woods, railroads expanded into the region, offering connections by stage or steamboat to the many hotels being built in the area. Moosehead boasted several great houses, perhaps the grandest being the Mount Kineo House. Around 1845, a small tavern was erected at the base of Mount Kineo, and in 1848, the first Mount Kineo House opened. This small facility burned in 1868, and in 1871, a newer and grander second house opened. In early 1882, this house was remodeled and expanded but succumbed to fire just a few short months later.

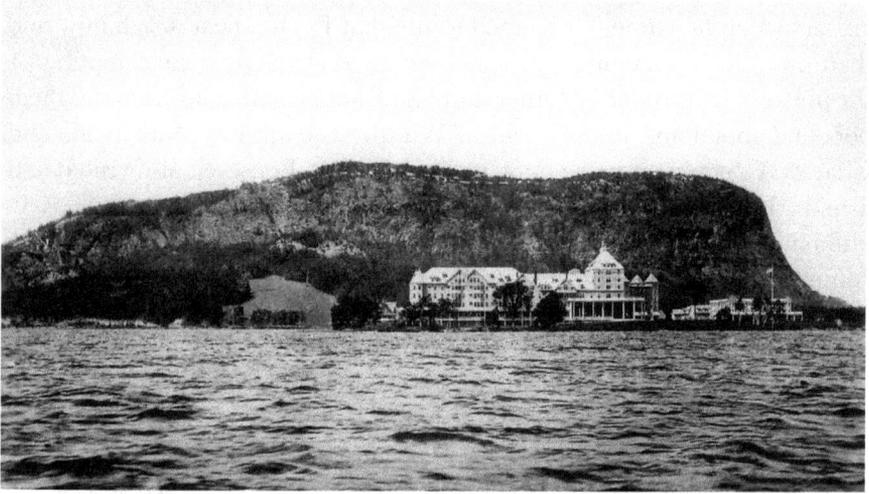

View of Mount Kineo House from Moosehead Lake, no date. *Collection of author James E. Benson.*

An advertisement for the Mount Kineo House published in *Hubbard's Guide to Moosehead Lake and Northern Maine* in 1882 boasted of the region:

> *Mountain, crag, hill, valley, lake, island, all lend their aid to weave a picture, the description of whose beauties passes the power of man. The dense, deep, primeval forests, silent and gloomy; the mountains frowning in their majesty; the lake bathed in the glory of the sunshine; islands rising here and there as if by enchantment; the dark clouds gathering in the west and piling themselves in endless confusion athwart the sky; the spray and mist through whose thin glimmering some mountain becomes a veiled picture; in the far distance Katahdin lifting its head above the clouds and sending back answering signals to "Great Spencer" and "Big Squaw"—all these and countless others, afford a picture wherein the*
>
> GRAND, THE SUBLIME, AND THE PICTURESQUE
>
> *are harmoniously blended, and which cannot fail of leaving a lasting impression for good on the mind and life of the beholder.*[18]

The grandest of the Mount Kineo Houses opened in 1884. This house was described in an 1889 advertising pamphlet:

This hotel is planned on an ample scale and believed to be second to none in construction, general arrangement and convenience, as well as in its provision for the security and comfort of its guests. The dining room is 100 x 51 feet, seating four hundred people. Particular attention has been paid to the sanitary arrangements and drainage. The sleeping rooms are large, light, all provided with the best of mattresses and springs, and reached by broad stairways or steam elevator. Every room commands an excellent view of lake and mountain scenery. A piazza fifteen feet wide extends around the main house.[19]

In 1911, following the acquisition of the hotel by the Maine Central Railroad, the Hiram Ricker Hotel Company assumed management of the hotel, which had been enlarged and upgraded. At this time, it was the largest inland waterfront hotel in America. In 1933, the Maine Central closed its Kineo branch and, in 1938, sold the hotel property to a group of local investors on the condition that the railroad company tear down the main hotel, leaving the annex and cabins. The advent of World War II changed several plans for the property, and various attempts were made into the early 1990s to renovate the annex until 1995, when the deteriorating buildings remaining were demolished.

The beauty of Moosehead, the water, the clean air and the world-class fishing drew sportsmen by the hundreds to the hotels and sporting camps of the lake. Local businessmen traveled to shows in New York, Boston and other cities promoting the fishing and hunting. Stories of great landlocked salmon, brook trout and togue enticed sportsmen to travel great distances to Moosehead's shores. In her book *The Lakes of Maine*, Daphne Winslow Merrill told of fishermen in 1866 catching thirty tons of fish in the winter and ten more during the summer and shipping it to New York and Boston, where it sold for twelve cents per pound.[20] Fish and game rules of the 1880s eliminated this type of over-fishing by establishing length limits and limiting a person's possession of fish to fifty pounds. In 1916, *Hilltop Magazine* ran an article in which it stated:

The fishing still keeps up and the catches are beyond those of all recent years. A remarkable string, caught in the South Branch of the Penobscot by Mr. Lloyd E. Byard of Haverhill, Mass., in two hours, consisted of twenty-six speckled trout that totaled over thirty pounds. The prize fish of the week was a six-pound land-locked salmon, taken by Mr. B.H. Osborne of Lewiston, Me. So good is the fishing that a bellboy casting a line off

Postcard of fish caught at Moosehead Lake, no date. *Collection of author James E. Benson.*

View of boats on Moosehead Lake taken at MacKenzie's West Outlet Camp, no date. *Collection of author James E. Benson.*

the wharf, took a five-pound trout in a few minutes casting, and it was a
square-tail, the fish most sought by the experts.[21]

What every Moosehead fisherman waits to hear is the call "ICE OUT." This call traditionally has signaled that the waters of Moosehead Lake are free of ice to the point that the lake is navigable its entire forty-mile length. Official records of the "ice out" date on Moosehead have been kept since 1848. It has been considered by many sportsmen that the weeks following the absence of ice on the lake are the best time to fish, and many sportsmen wait for that call to this day.

In 1928, that call came on May 12, when Russell P. Spinney, owner of Tomhegan Camps (located some twenty-four miles up Moosehead), sent a telegram to a group of civic and industrial leaders in Brockton, Massachusetts, that read, "Conditions favorable, all ready for you."[22]

"ALL READY FOR YOU"

I n Brockton, Massachusetts, a group of businessmen and civic leaders waited like anxious schoolboys for the ice to leave the waters of Moosehead Lake in the north woods of Maine so that they could embark on their annual two-week fishing trip. The group had made arrangements with Russell P. Spinney, owner of the Tomhegan Camps a distance up the western shore of Moosehead, to stay at his camps, as they had in the past.

They had intended to leave for Moosehead as early as May 1, but the lake was still ice-bound at that time. They awaited word from Spinney that the ice had left the lake. That word came by telegram on Saturday, May 12, with the message, "Conditions favorable, all ready for you." At 4:00 a.m. on Sunday, May 13, Mother's Day, Fire Chief William F. Daley, former mayor Harry C. Howard, police captain James E. Lays, highway commissioner G. Fred Dahlborg, Plymouth County Sheriff Earl P. Blake, city physician Dr. Arthur S. Peterson, dentist Dr. Frank Moberg, physician Dr. David Bridgwood and businessmen John Sandberg and Knute Salander loaded themselves into three automobiles—one belonging to John Sandberg, another to Fred Dahlborg and the third to Sheriff Blake— to begin the grueling ride north. Others were to have joined them but did not, among them Clerk of Courts Charles F. King and probation officer Charles A. Parris. King and Parris remained at home, as Judge C. Carroll King was seriously ill and would die later on May 13.[23]

Newspaper reports vary on the time that the group reached Greenville. One article says they arrived at Greenville at 3:00 p.m. and were on the

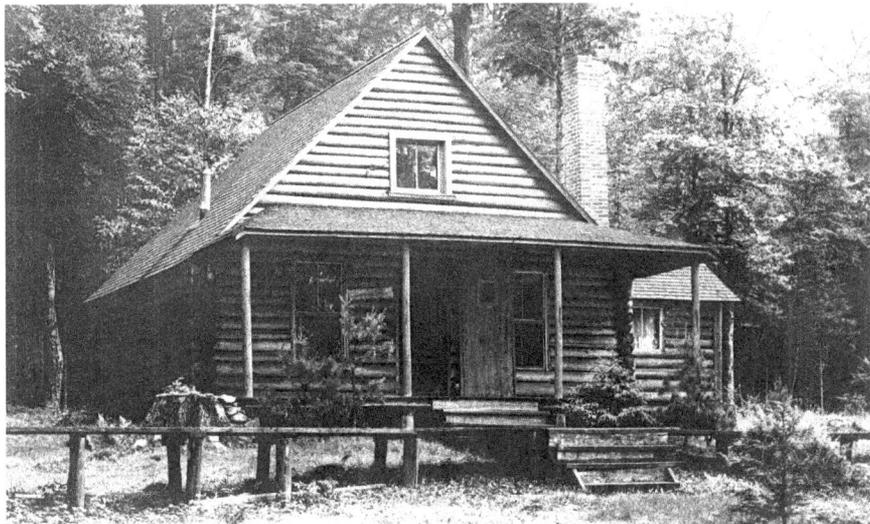

Tomhegan Camps fishing cabin, circa 1924. *Collection of author James E. Benson.*

lake at 5:30 p.m.,[24] while another gives the arrival time at Greenville at 6:00 p.m.[25] and yet a third says they arrived in Greenville at noon and left the dock at 4:40 p.m.[26] The distance from Brockton to Greenville was approximately 330 road miles, and although it is not recorded what the men were driving for vehicles, it is known that the Maine state highway system was excellent and went right to Greenville; it would not have been unusual for a Ford Model A of the period to travel a good road at forty to fifty miles per hour, which would make the noontime arrival feasible.

The Brockton party met its Maine guide and boat operator, Samuel Budden, at the dock and loaded the gear onto the *Mac II*, built and owned by Greenville resident J. Fred Sawyer. The *Mac II* was a speedboat well known on the waters of Moosehead for its transporting "sports" and tourists to and from the lake's camps and hotels. Once again, newspaper reports differ on the size of the *Mac II*—one report says the boat was forty-five feet in length with a ten-foot beam,[27] while another says it was thirty-three feet long with a seven-foot beam.[28] It is also reported that the boat could easily travel in excess of thirty miles per hour with its 145-horsepower engine. With a capacity for eighteen passengers, the boat was not overloaded with ten plus the operator.[29] As the boat left the dock, the wind was blowing heavy from the north, and the weather was described as "thick." The large open expanse of Moosehead allowed for the wind to pile up heavy seas on the cold lake,

whose shores, coves and inlets were still awash with broken-up ice. It was into the cold wind and turbulent sea that the *Mac II* headed, and as Captain James Lays would later recall, "Everything was going smoothly although the water was rough...we were headed for Spinney's camp."[30]

The *Mac II* plowed through the waves until it was about eighteen miles from Greenville and still six miles from its destination, at which time Captain Lays saw about an inch of water on the floorboards of the boat. Lays later recounted to *Brockton Enterprise* reporter Thomas Sullivan that

> *I shouted to one of the boys to call the skipper aft, took up the floor board and saw the water steadily pouring in through a bad leak.*
>
> *We got the pump to working and at first we were successful in bailing the water out. A little later, however, the leak broadened and again the water poured in under the floor boards. "We are losing ground" I said to the boys. "It is getting the best of us."*
>
> *We then began to bail furiously but without material result. The water reached the engine and the power stopped. The skipper told us to get life preservers and then the boat began to sink rapidly.*
>
> *A little later, Dr. Bridgwood jumped overboard and started to swim toward shore. I jumped with him and exerted every ounce of power in my body* [to swim] *nearly three-quarters of a mile to shore. When we took*

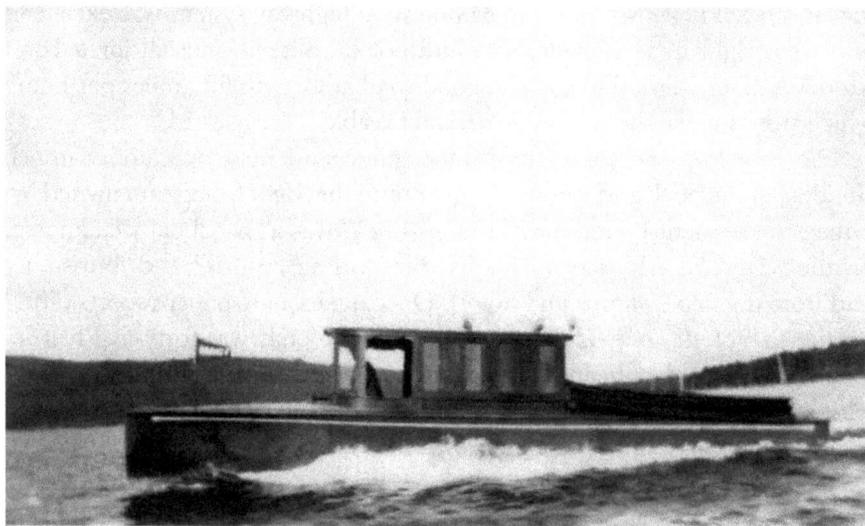

The *Mac II* speedboat, no date. *Courtesy the Moosehead Marine Museum.*

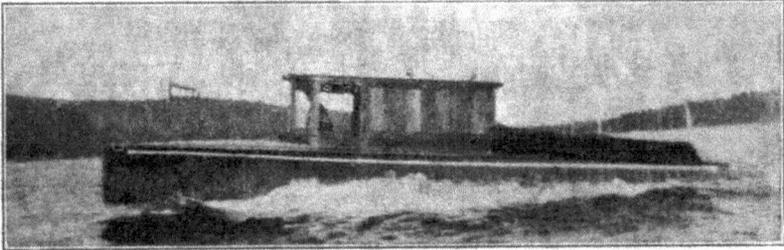

J. FRED SAWYER, GREENVILLE, MAINE

Fast Motor Boat Service to All Points on Moosehead Lake

Auto Storage Connected With Boat House
TELEPHONE CONNECTION

Business card of J. Fred Sawyer, owner of the *Mac II*, no date. *Courtesy the Moosehead Marine Museum.*

to the water it was nearly knee-deep in the boat and I was afraid it was going to capsize.

I had grabbed a stout piece of board and life-preserver before diving overboard.

The lake looked awfully cold but I took my chance. I grabbed a life preserver and dove in. The water was terrifically cold and I didn't think I would ever make it.[31]

Captain Lays described being in the water, and before heading for shore, he looked behind him toward the boat as he rode the crest of a wave and saw several of his friends clinging to the boat. As the furious lake broke over him again, he looked back once more to where he had last seen his friends and saw nothing. Lays continued his account:

When away from the boat and somewhat rid of the first shock of the water I looked around. Several yards behind me and seemingly swimming strongly was "Doc" Bridgwood. He looked O.K. I could see other forms in the water and one behind Bridgwood looked like Dr. Peterson.

In a few minutes the water worked through my automobile and fishing clothing. It was a terrible battle every minute to keep my head above water and headed towards shore. When I reached it I was on the verge of collapse. I stayed on the shore until I got my wind and strength.[32]

31

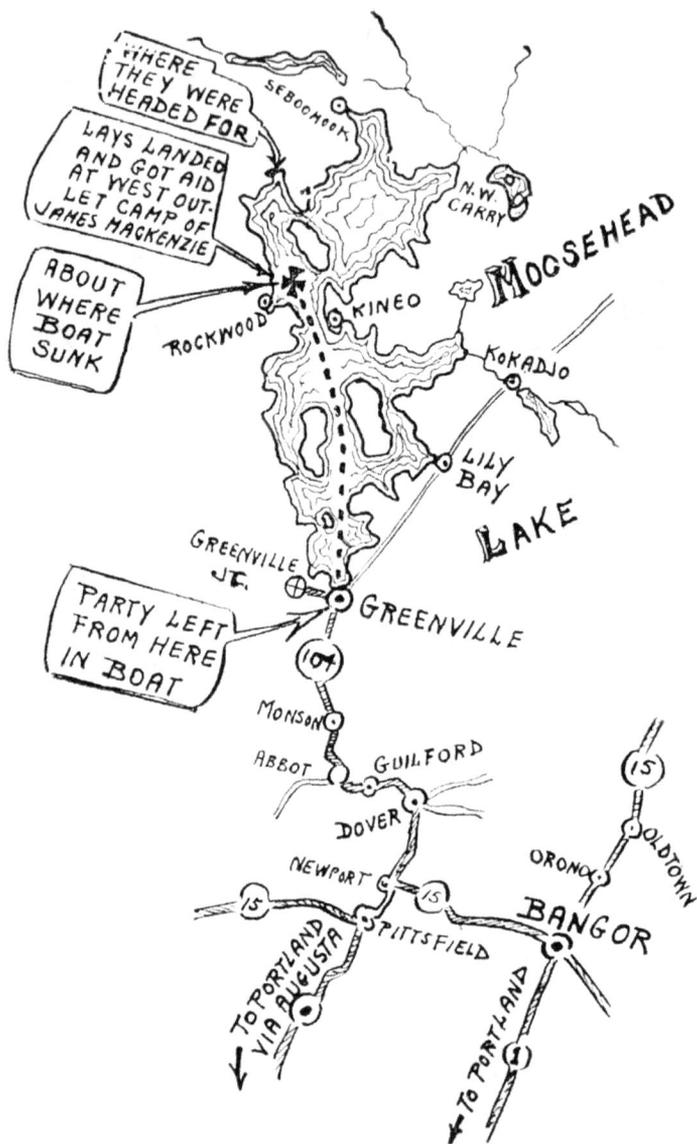

Hand-drawn map illustrating location of events, from the *Brockton Daily Enterprise*, May 15, 1928. *Courtesy the Brockton Historical Society.*

Lays, cold and exhausted, reached the shore after dark. Hoping that some of his friends had swum to shore, he called out in the darkness but to no avail—no answers came. Making his way along the shore, he finally came across a cottage and recalled:

> *How I reached the camp I do not know. It took every bit of strength I had left to break the hasp off the door. I fell inside. A few minutes later I got a match safe out of my pocket and scraped together enough wood to build a fire. That's all I remember for several hours. I was pretty well dried out when I came to.*[33]

It was nearly dawn on Monday, May 14, when Captain Lays awoke and ventured outside the cottage refuge, owned by E.L. Malone of New York. Locating a trail that led from the cottage, he made his way to the West Outlet Camps about a mile away. Frank A. MacKenzie, one of the camp's proprietors, recounted the story of Lays arriving at his camps to the *Brockton Enterprise*:

> *At 4:30 o'clock this morning I was awakened by one of my guests at my camp who said that a man had wandered into the camp, stating that he had swam ashore from a wrecked motorboat and all his companions were drowned.*
>
> *I went to see him and found that it was Capt. James E. Lays of the Brockton police department, who was then in pretty bad shape. He said that he thought he was the only one saved.*
>
> *…The disaster happened about one-quarter of a mile off shore about a mile below my camp. After being given warm clothing, food and medicine Capt. Lays recovered strength and left for the hotel in Greenville Junction.*
>
> *…Capt. Lays said that all the men had on heavy clothing for the auto ride from Brockton and that one of the party was wearing a fur coat, which he was undoubtedly wearing in the motorboat.*
>
> *This morning all of the members of my camp visited every cottage along the shores for several miles and we feel positive that no one was saved but Capt. Lays.*
>
> *About 9 o'clock this morning parts of the wreckage from the boat were discovered on the shore, but no bodies were washed in, although there was a heavy wind blowing towards shore.*
>
> *Early this morning Medical Examiner, Dr. F.J. Pritham of Piscataquis county and Sheriff L. Rogers made preparations for dragging the lake for the bodies of the other members of the party.*[34]

Left: Medical examiner Dr. F.J. Pritham of Piscataquis County, Maine, no date. *Courtesy the Moosehead Historical Society.*

Right: Mayor Harold D. Bent, no date. *Collection of author James E. Benson.*

News of the tragedy reached Brockton shortly before noon on Monday, May 14, via a telegram from Piscataquis County deputy sheriff Adelbert G. Rogers of Greenville to Brockton Mayor Harold Bent. It was Captain Lays who broke the news of the tragedy to the *Brockton Enterprise* via a long-distance phone call. The headline of the paper on May 14 after that call read:

9 LOCAL, ONE PLYMOUTH MAN
FEARED DROWNED IN MAINE LAKE

Capt. James E. Lays Alone Known Safe—Party of 10 Including Also
G. Fred Dahlborg, Fire Chief Wm. F. Daley, Sheriff Earl P. Blake, Dr.
A.F. Peterson, Dr. David Bridgwood, Knute Salander, John Sandberg,
Dr. Frank W. Moberg and Harry C. Howard, Pitched into Water on
Way to Moosehead Lake Camp for Fortnight of Fishing—Most of Party
Missing, According to Meagre Message from Captain Lays Who Tells
Enterprise His Story.

A sub-headline read:

*SERIOUS CONDITION OF POLICE OFFICIAL AND DIFFICULTY IN GETTING
DETAILS FROM LAKE REGION FAR AWAY FROM SETTLED COUNTRY
MAKE TASK OF GETTING EXACT FACTS QUICKLY, EXTREMELY HARD.*[35]

This headline proved to be true, as misinformation was passed on and reported. Perhaps poor telephone connections were to blame, as news articles varied on the names of local persons involved in the aftermath, conjecture as to what happened to the boat to cause the sinking and even a report that the survivor was Fire Chief William Daley.[36]

Meanwhile, back in Greenville, Captain Lays had been taken from the Piscataquis Exchange Hotel in Greenville Junction and brought to the Charles A. Dean Hospital, where he was listed on the danger list, with serious lapses in memory. As remote as it was, Greenville was fortunate to have the hospital, built in 1911 by the Hollingsworth & Whitney logging company. Mr. E.L. Dean, one of Greenville's selectmen, reported that the account of what happened given by Lays was somewhat vague because of problems with his mental situation. Dean further reported that Lays could not fully recount what happened after the boat began to take on water.[37] In all likelihood, Lays was suffering from hypothermia, a condition that may have claimed the lives of his fellow fishermen.

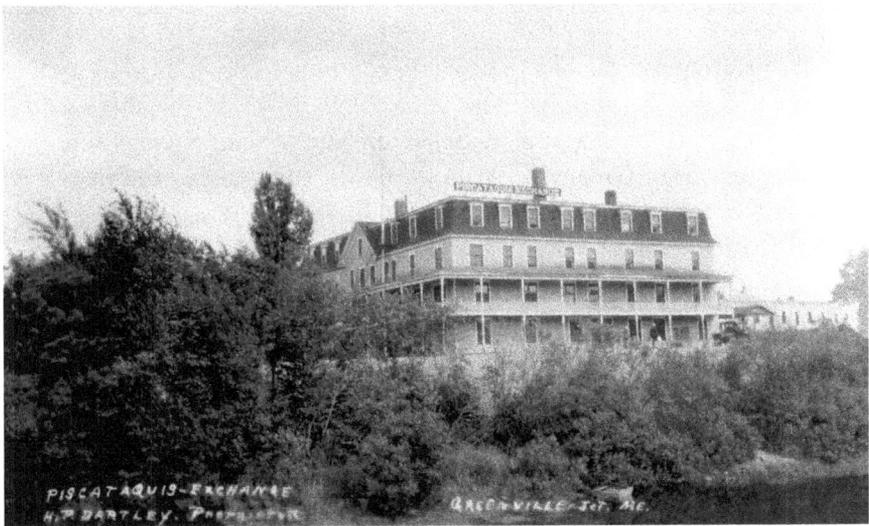

View of Piscataquis Exchange Hotel, Greenville, Maine, where Captain Lays stayed during recovery operations, no date. *Collection of author James E. Benson.*

Advertisement for Piscataquis Exchange Hotel, from the *Maine Register*, 1928. *Collection of author James E. Benson.*

At home in Brockton, word began to spread rapidly throughout the city and region. Hope reigned in the hearts and minds of family and friends that they might still receive good news from Greenville. Immediately, some family members and friends headed north to aid in the search and to be with Captain Lays. Among the first to head north were the captain's brother, Deputy Sheriff Samuel T. Lays; the captain's son Roger; Dr. Fred R. French; and police inspector William S. Hill, who left by automobile shortly after receiving word of the tragedy. In all, more than a dozen relatives would journey in desperation by plane, train and automobile to the shores of Moosehead Lake to aid as they were able in the search.

In order to be sure that the latest details were reported to Brockton, the *Brockton Enterprise* contacted the East Boston Airport Corporation and gave orders that no expense was to be spared to hire an aircraft to fly its staff to Maine. Men from the newspaper headed to the airport with the plan that if a plane were not available, they would continue to drive to Moosehead. Disappointed that a hydroplane was not available, a Travel Air three-seater was acquired to take telegraph editor Joseph Messier and city hall reporter Thomas Sullivan to Greenville. With A. Lewis MacClain as the pilot, the plane, similar to that flown by Charles Lindbergh to Paris the year before, took off. With a top speed of 120 miles per hour and 250 air miles to cover, with a refueling stop at Old Orchard Beach Maine, the trio hoped to be in Greenville before dark. At 7:55 p.m., Messier telephoned the newspaper office that they had landed safely at Greenville.[38]

The *Enterprise* was keeping its offices open until midnight to answer calls from people inquiring about the incident. The *Boston Globe* reported in its morning edition on Tuesday, May 15, that "all along the principal streets of the city of Brockton, little groups gathered to discuss the tragedy. Hundreds of homes were filled with the sorrow that comes with death, especially that feeling of loneliness that comes upon relatives without warning of

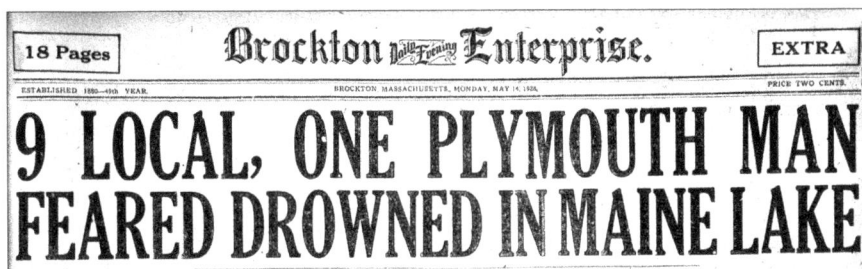

Brockton Daily Evening Enterprise.

18 Pages — EXTRA

ESTABLISHED 1880—49th YEAR. — BROCKTON MASSACHUSETTS, MONDAY, MAY 14, 1928. — PRICE TWO CENTS.

9 LOCAL, ONE PLYMOUTH MAN FEARED DROWNED IN MAINE LAKE

Brockton Daily Enterprise headline, May 14, 1928. *Courtesy the Brockton Historical Society.*

impending danger.…[T]housands of people gathered in the streets to listen to the megaphoned bulletins."[39] Not since Brockton's Grover Disaster of 1905—when the massive steam boiler of the Grover shoe factory exploded without warning and rocketed through the structure, killing fifty-six and maiming scores more—had an event so shocked the city and brought crowds to the streets in mourning.

The scenes at the homes of those men lost on the lake seemed almost surreal. As the *Enterprise* reported, "At the Salander home on Hillberg Avenue where slept two babes, one of two and a half years [Virginia] and the other [Donald] of thirteen months, mercifully too young to realize the enormity of their loss, Mrs. Ebba Salander turned and tossed in an agony of despair unaided by the palliative ether, tears or sleep. Her grief was dry-eyed, so piercing that she seemed on the point of spiritual numbness." Others in Salander's three-decker house shared in her disbelief. Robert A.T. Nelson and Oscar A. Johnson remarked to a reporter that their "night would hold no sleep until the Absence in that other chamber had been proven." Nelson further remarked, "I can't believe it, it can't be that they could all fail where Capt. Lays succeeded."[40]

At the Howard home on Moraine Street, Alice Howard was comforted by her sister and brother-in-law, Mr. and Mrs. George Otis, and family friends architect Ralph P. Jackson and his wife, hoping against hope that good news would soon come about her husband, Harry. In nearby Plymouth at the county farm, the prisoners and the guards spoke with one another about Sheriff Earl Blake, and the sentiment among all was, "We've lost a good friend."[41] At the Brockton Police Station, Mrs. Lays awaited further communications from her husband; nervously concerned over his condition, she collapsed at the station and was brought home to rest. Captain Lays, speaking by phone to Mayor Bent, directed the mayor to "tell my wife that I am O.K. and will be home as soon as things are straightened out up here."[42]

Knute and Ebba Salander, circa 1920s. *Courtesy Todd von Hoffmann.*

News of the incident, sporadic as it was, would come across the airwaves and be broadcast over the radio into homes such as that of the family of Dr. David Bridgwood, whose elderly parents waited in despair for news of their son's fate. At the Peterson home, the doctor's wife, Sarah, would "gaze sadly at the innocent faces of her two slumbering small sons [Robert and Alan]."[43] Mrs. Peterson was very familiar with the Moosehead region as well as the boat the *Mac II*, as she had visited many times with her husband and most recently had gone in the company of John and Alma Sandberg. At about 10:00 p.m. on Monday, friends arrived at the Peterson home to share news that they had heard on the radio that Dr. Peterson had been found alive. Dr. M.G. Sawtell, who was watching over Mrs. Peterson, had sent her to rest and kept visitors from her. This latest news from the radio was kept from her, fearing that it may not be true.[44]

Chief Daley's wife, Nora, refused to believe that her husband was dead when she received the news on Monday morning. As the day progressed, however, she gave in to the fact since she had not received a telegram or telephone call from him. Friends reported that Daley originally was enthusiastic about the fishing trip but was more hesitant when the trip was delayed because of ice on the lake. The delay would prevent him from going

with his wife to the annual Policeman's Ball, but he decided to go to Maine as to not break up the fishing party.[45]

Believing her husband was in no danger while he was on his fishing trip, Sheriff Blake's wife, Louise, had gone to Swampscott on Monday morning to attend the Massachusetts Federation of Women's Clubs convention as a delegate from the Plymouth Women's Club. Upon hearing the news of the accident that evening, she collapsed. She was accompanied home to Plymouth by Secretary of State Frederic W. Cook and his wife, who were close friends of the Blakes' and also attending the convention.[46]

As the city reeled from the enormity of this event, Mayor Harold Bent ordered all flags in the city to be flown at half-mast and asked that for several days at least social events be canceled unless it was absolutely necessary to hold them. Among the events canceled or postponed were the annual Policeman's Ball, the meeting of the newly formed Massachusetts Fire Chief's Association, the New England League Baseball Club parade, a meeting of city Democrats promoting Brockton native and Texas oilman Edgar B. Davis for vice president of the United States and the Brockton Visiting Nurse Association's mammoth bridge party, which was expected to draw more than 1,200 people to the tables, among many other events.

On Tuesday, May 15, the newspaper headlines read, "No Bodies Are Recovered May Employ Navy Divers," as more than 150 men and boats of all sizes searched the waters of Moosehead for the remains of the victims.[47] With Deputy Sheriff Samuel Lays heading to the scene at Greenville, Mayor Bent issued him the following order prior to leaving: "I ask you in the name of the city to make every possible effort to bring back to Brockton, dead or alive, those of the men that are reported missing." Additionally, the mayor ordered, "I am taking the liberty to say that the city will spare no expense to further the search at Moosehead Lake."[48]

In response to the mayor's order to Lays, the governor of Maine, Ralph Owen Brewster, offered all of the resources of the State of Maine to assist in the search. The governor had been strongly encouraged to make this offer by Morris McDonald, president of the Maine Central Railroad. McDonald wanted all the bodies recovered.[49] Perhaps McDonald had the best interests of his railroad at heart when pushing the governor for this action. The Somerset branch of the Maine Central ran directly to Rockwood, where it provided direct access by steamer to the railroad's grand Mount Kineo House, and McDonald obviously did not want to put a fear of recreating on the lake into his customers' minds. Brewster immediately contacted Piscataquis County Sheriff John H. Weymouth and let him know that he

Somerset Railroad Station, Somerset, Maine, circa 1913. *Collection of author James E. Benson.*

wanted every possible effort made to assist by offering the help of the State Fish and Game and Forestry Departments, the state highway police and the Maine National Guard if needed. The commissioner of the Maine Forestry Department, Neil Violette, headed to Greenville immediately. Governor Brewster then sent a message to Mayor Bent in which he said, "Will you convey to your citizens the profound sympathy of the citizens of Maine in the tragic loss which you have suffered. Every resource at our command is being used to recover the bodies without delay and we hope that we can soon advise that these efforts have met with success."[50] Mayor Bent, having personally taken charge of the work being done in Brockton, stayed in his office around the clock answering telephone inquiries and consoling the family members of those lost. Surrounded by members of city government, Bent listened to everyone and acted on almost everything to be certain that nothing was overlooked.

Help was being offered from everywhere. Brockton shoe industrialist Eversleigh R. Laird, a neighbor of Harry Howard's on Moraine Street, called his employees at his last factory in Bingham, Maine, upon learning of the incident and ordered them take his sixty-foot boat, known to be the largest and most powerful on Moosehead, to Greenville and place it along with themselves at the disposal of the search teams.[51] Crews in boats and canoes with grappling irons worked the lake bottom in anywhere from thirty

Left: Morris MacDonald was president of the Maine and Central Railroad in 1928 and influential in convincing Maine governor Brewster to offer the resources of the state in the recovery of the bodies. Photo circa 1913–14, when Morris served as president of Boston-Maine Railroad. *Courtesy the Library of Congress, Prints and Photographs Division, LC-DIG-ggbain-13591.*

Right: Maine governor Ralph Owen Brewster, circa 1930. *Collection of author James E. Benson.*

to one hundred feet of water hoping to catch hold of a body or of the ill-fated boat. An unidentified local doctor, referred to only as a "prominent local physician," speculated that it would be as many as eight to ten days before the lake would begin to give up its dead. He is quoted as saying, "Cold water tends to retard putrification. For that reason the gas forming bacteria will function at only a minimum although their activity will not entirely be stopped. These bacteria, always present in a body, feed on dead tissue and prefer warmth to cold. Cold makes them sluggish and so the gases which their metabolisms create and which are responsible for the rising to the surface of a dead body in water, gather much slower than ordinary."[52]

As the search continued, offers came in from divers throughout the Northeast to come and aid in the search. Among the first to volunteer to head north was Brockton firefighter Walter F. McLaren, who was assigned to Ladder No. 1. McLaren was an expert diver, having graduated from the U.S. Navy diving school. McLaren had been part of the diving team involved in the recovery efforts of the 1904 *General Slocum* disaster in New York.

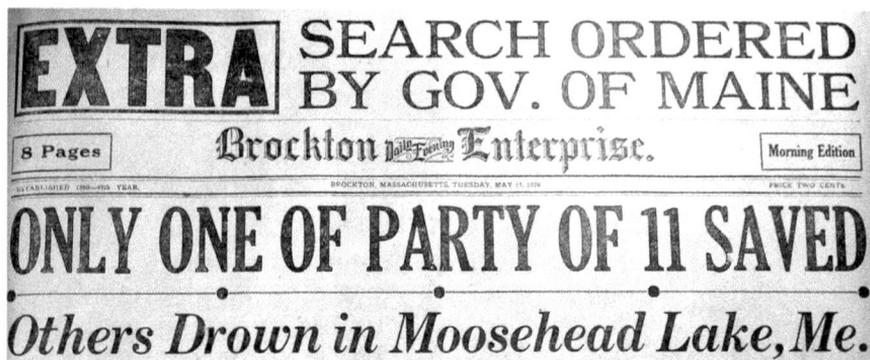

EXTRA SEARCH ORDERED BY GOV. OF MAINE

8 Pages · Brockton Daily Evening Enterprise. · Morning Edition

ESTABLISHED 1880—49th YEAR. · BROCKTON, MASSACHUSETTS, TUESDAY, MAY 15, 1928 · PRICE TWO CENTS

ONLY ONE OF PARTY OF 11 SAVED

Others Drown in Moosehead Lake, Me.

Brockton Daily Enterprise headline, May 15, 1928. *Courtesy the Brockton Historical Society.*

Carrying 1,021 passengers—mainly women and children—on a trip along New York's East River chartered by St. Mark's Lutheran Church, located on New York's heavily German Lower East Side, the *General Slocum* caught fire during the trip, sending many of its passengers to a watery grave. Only 321 survived.[53] Until the events of September 11, 2001, this was the largest loss of life in the United States not due to weather or war.[54] First Assistant Fire Chief Frank Dickinson, who had temporary command of the department, gave McLaren permission to go to Greenville.

Mayor Bent also received a visit from Frederick J. Wallace of Somerville, Massachusetts, offering his services as a diver, as well as enough diving equipment to outfit three men. Bent did not accept his services, as Governor Brewster did not think it wise to attempt to recover the bodies of ten men in this manner.[55] Also offering his services was navy diver Thomas Eadie, famous for his unsuccessful dive to rescue the crew of the USS *S-4*, a submarine that was accidentally struck by a Coast Guard boat on "rum patrol" off Cape Cod just five months before the tragedy on Moosehead. The sub's crew of forty perished, and Eadie saved a fellow diver who had become entangled in the wreckage. For his bravery, Eadie received the Medal of Honor on December 18, 1927.[56] Brockton police officer John F. Sullivan also offered his services as a diver, having served in the navy for eight years.

The Maine State Fish and Game Department sent seven men under the command of Fish and Game Warden George Stobie to set up operations at the West Outlet Camps, assigned with the task of locating the boat and the lost men. Stobie, born in Scotland, would be named Fish and Game commissioner in 1929, a position he would hold until his retirement in 1950.[57] Also operating out of the West Outlet Camps was *Enterprise* reporter

View of cabin of the West Outlet Camp, where search operations commenced. *Collection of author James E. Benson.*

Image overlooking Moosehead Lake from MacKenzie's West Outlet Camp, Maine, circa 1930s. *Collection of author James E. Benson.*

Thomas Sullivan, who was intent on providing the citizens back home with evidence of the great efforts occurring more than three hundred miles away. Sullivan borrowed the only camera at the camps, as well as the only film available, and shot pictures of the recovery efforts. Sullivan chartered the *Clematis*, a boat known for its speed, to take him to Greenville, where he could send the film on to Brockton. While the boat's owner, Walter Taylor, oiled and cared for the engine, Sullivan piloted the craft with one hand, writing captions for his photos with the other.[58]

CHAPTER 3

THE LAKE GIVES UP ITS DEAD

At 12:10 p.m., Daylight Savings Time, on May 16, the lake gave up the body of Dr. David Bridgwood. His body was brought to the surface by game wardens of the state forestry service Charles Green, Edward Lowell, Henry Perley and Harley Budden, brother to the boat's skipper who had been working in about sixty feet of water some three hundred feet off shore. The body was kept just below the surface between two boats as the men brought it toward shore. A boat containing Captain Lays, his brother, Dr. Frank French and reporter Sullivan pulled alongside. Dr. French nodded upon looking at the body, with Captain Lays nodding back and saying, "That's Doc." Bridgwood's body was brought to Greenville Junction where, upon orders from Mayor Bent, it was placed in the care of Orville Harvey, the local undertaker, who was to prepare the body for transport to Brockton. Dr. French recovered from Bridgwood's body $175 in cash and his watch, the hands of which had stopped at 6:10. The doctor's family was notified by the *Enterprise* that he had been found, and they made arrangements with the E.T. and N. Sampson Funeral Home to coordinate with Harvey to transport the body to Brockton and take charge of the funeral arrangements. Dr. Bridgwood's body was returned to Brockton by train, and funeral services were scheduled for 3:00 p.m. Sunday, May 20, at St. Paul's Episcopal Church, with Rector David B. Matthews, STD, officiating.[59]

As the search for more bodies continued, Frank MacKenzie, owner of the West Outlet Camps, offered two motorboats and chains with which to drag the bottom. MacKenzie told the rescuers from Brockton, "What

J. Fred Sawyer, no date. *Courtesy the Moosehead Historical Society.*

I have is yours. Go to it." During the recovery efforts, a federal steamboat inspector arrived on scene and began his investigation. Maine state authorities were also engaged in their own investigation, including interviews with the boat's owner, Fred Sawyer, who could give no reason for the sinking. As the investigation continued, Deputy Sheriff Rogers gave permission to a group of Brockton men who had come up immediately following the tragedy to return home on Wednesday, May 16, taking with them the personal effects of the men that had been recovered as they floated to the surface and washed up on the shore. The three automobiles that the men had driven to Greenville were released to C. Emil Dahlborg, brother of Fred Dahlborg; Carl Lawson; Dr. William T. Weston; Charles Bridgwood, brother of Dr. Bridgwood; Dr. Henry F. Weston; Arthur Moberg, brother of Dr. Frank Moberg; E.G. Taft, an intimate friend of Chief Daley's from Cohasset, Massachusetts; William S. Hill, acting inspector of the Brockton Police department; Alan Lays, son of Captain Lays; and *Enterprise* reporter Joseph Messier.[60]

As the recovery progressed, heavy ropes were delivered from Waterville, Maine, to the south, and local blacksmiths were busy at their forges making more grappling hooks. Another skilled diver arrived on the scene at Moosehead. Bickford Brooks, a skilled deep-sea diver from Kennebunkport, Maine, was asked to come to the lake, departing for Greenville on Wednesday, May 16. Brooks brought with him diving equipment capable of reaching depths of four to six hundred feet. Accompanying Brooks on the trip were pump tenders H.H. Jewett, Edward Baker, Howard Brooks and Israel Jacobson, and the group was driven by Brooks's wife. Being questioned by reporters before leaving Kennebunkport, Brooks replied, "I'm pretty busy, you might talk to my wife over there in the car, she is driving up through the night, I don't drive a car myself."[61] Upon arrival at Greenville, Brooks set up all of his equipment on a scow that would operate at the scene as his base of operation. It was suggested to Mayor Bent that Brooks may want to

use an underwater searchlight or underwater telescope, and arrangements were made with the Charlestown Navy Yard in Boston to have them shipped north if necessary.[62]

As Dr. Bridgwood's body was nearing Brockton by train, and as the friends and automobiles of those men drowned were en route to Brockton on May 17, the body of Knute S. Salander was brought up from the depths by wardens Green and Lowell, the same men who had recovered the body of Dr. Bridgwood. Once identified by Captain Lays and others, Salander's body was brought to shore by the wardens, who were careful to keep it slightly below the surface so as to preserve its good condition. The body was found five hundred yards off shore and about three hundred yards from where Dr. Bridgwood's body had been recovered, as well as about one hundred feet from where it was thought the *Mac II* sank. Salander's body was taken to Greenville by undertaker Harvey, who prepared it for transport to Brockton, where Salander's widow, Ebba, had made arrangements through Mayor Bent to have funeral plans handled by C. Emil Dahlborg, the brother of Fred Dahlborg, an undertaker in Brockton.[63] Undertaker Dahlborg had worked with Harvey while he was in Greenville to be certain that Harvey would prepare all of the bodies as soon as they were found and removed from the cold water. In addition, Harvey made arrangements with his brother Carlton C. Harvey, an undertaker in nearby Guilford, Maine, to assist him as needed and ordered shipping caskets to come from Waterville, Maine. Harvey prepared all the bodies for transport to Brockton under the watch of Dahlborg; upon arrival in the city, they would be transferred to the undertaker of the family's choice.[64]

A short time after the body of Salander was recovered, the bodies of Fire Chief William F. Daley and highway commissioner G. Fred Dahlborg were brought to the surface. Dahlborg's hat was still on his head when his body was brought up. After being identified, they were brought to shore. Mayor Bent was immediately notified of the recovery, and he in turn broke the news to Nora Daley, widow of the chief. Emil Dahlborg was in the mayor's office when the call came in from Greenville of the discovery, and he left to break the news to his parents and family. The bodies of Daley and Dahlborg were brought up in close proximity to Salander and the assumed location of the boat.[65] Grappling hooks came up with green paint matching the color of the *Mac II*. Encouraged that the boat may have been found, the lake's largest steamer, the *Katahdin*, piloted by Captain Messervy, arrived on scene to serve as diver Brooks's base of operation. As grapplers worked the waters, they brought up a rubber coat identified by Captain Lays as belonging to

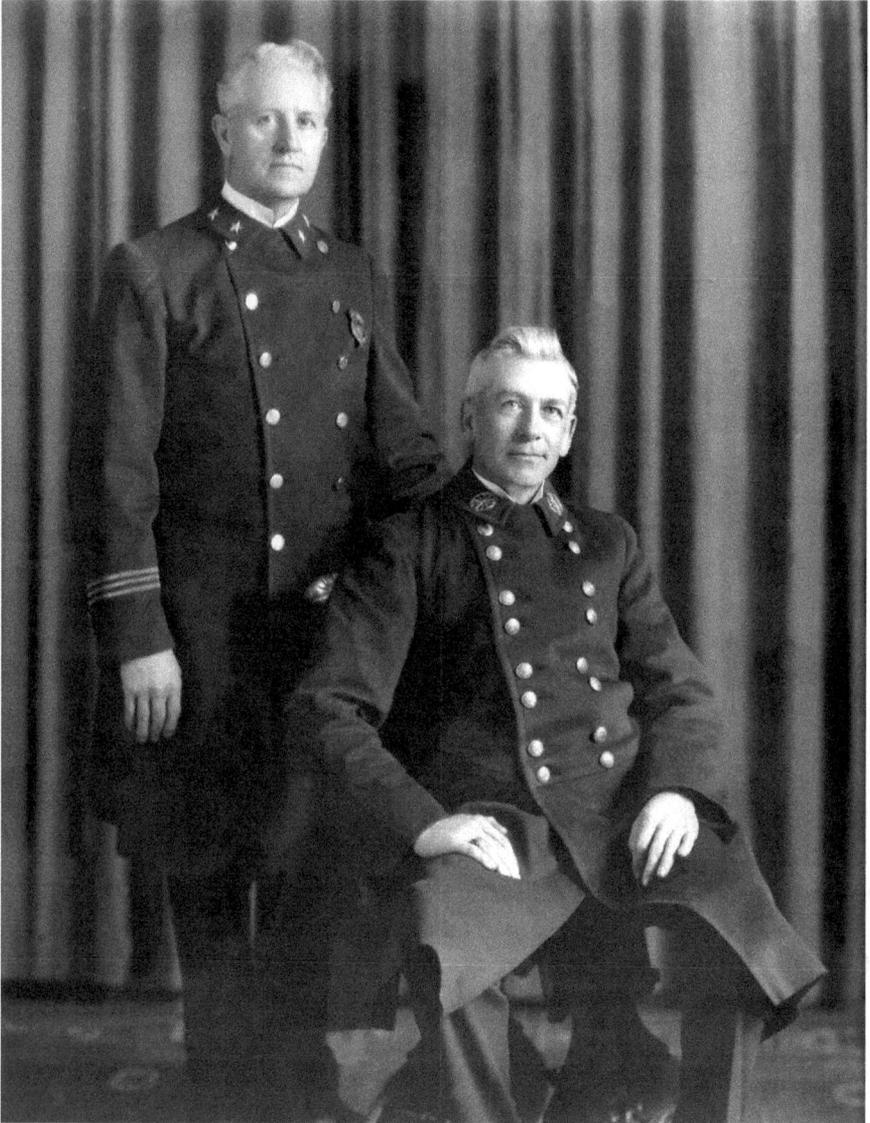

Police Captain James E. Lays (*left*) and Fire Chief William F. Daley, circa 1920s. *Courtesy the Brockton Fire Museum.*

Chief Daley, as well as a duffle bag whose owner was unknown. Joining the *Katahdin* was the steamer *Olivet.* Both steamers brought with them rafts of logs to use in the search. After breaking up the rafts, twenty or more of these logs were chained end to end, and one-hundred-foot-long ropes with

grappling irons on their ends were attached to the logs. The row of logs was then fastened between the two steamers, which pulled the string of logs back and forth. This allowed the hooks to drag the lake bottom.[66]

Diver Brooks dove down to where the *Mac II* was located in about sixty feet of water. Searching the boat, Brooks found clothing, luggage and fishing gear but no signs of any of the bodies still missing. Brooks described the bottom at this point in the lake as having as much as two feet of mud and a visibility of only about fifteen feet.[67] Late on Thursday, May 18, five days after the sinking, the body of Harry Howard was brought up near the spot where Daley had been found about five hundred yards off shore. Due to the location of the body, it was assumed that Howard had made it partway to shore. Howard's body was brought up by wardens Lowell and Green. Those at the scene were again eager to report that the body was in perfect condition, a commentary on the fact that the grappling irons had caught the clothing on the bodies and had avoided causing any mutilation of them.[68] Harley Budden, brother of the boat's skipper, Sam Budden, was among the men working the lake continuously. Budden worked day and night in hopes of bringing the body of his brother to the surface, and working alongside him was his close friend Henry Perley a full-blooded Penobscot Indian. Perley was familiar with Brockton, as some of the men were with him, when he had been a regular attendee of the Brockton Fair while traveling with a concession company.[69]

As the search continued for more bodies, Brockton undertaker Charles M. Hickey visited the Daley family, who desired to have the chief's body returned to Brockton as soon as possible. Arrangements were made to have the body flown back home. L.C. "Kiddy" Barrows, vice-president of the New England Air Craft Company, flew from Hartford, Connecticut, to Boston, where he picked up undertaker James Hickey to accompany him. The two flew in a cabin monoplane, refueling at Old Orchard Beach, Maine, before heading to Greenville, where they landed at Walden Farm just east of the town. Before Daley's body left Greenville, Reverend Frank Sloan held a service for him. The body was flown back to the East Boston airport and brought by hearse to Brockton.[70] When Chief Daley's body was brought to his home at 210 Highland Street, First Deputy Chief Frank F. Dickinson, Second Deputy Chief John Murphy, Lieutenant William H. Bussey of Squad A and Lieutenant Daniel Long of Ladder No. 1 carried the body inside.

As Daley's body was en route to Brockton, Harley Budden and Henry Perley used a grappling iron to free the body of Plymouth County Sheriff Earl Blake

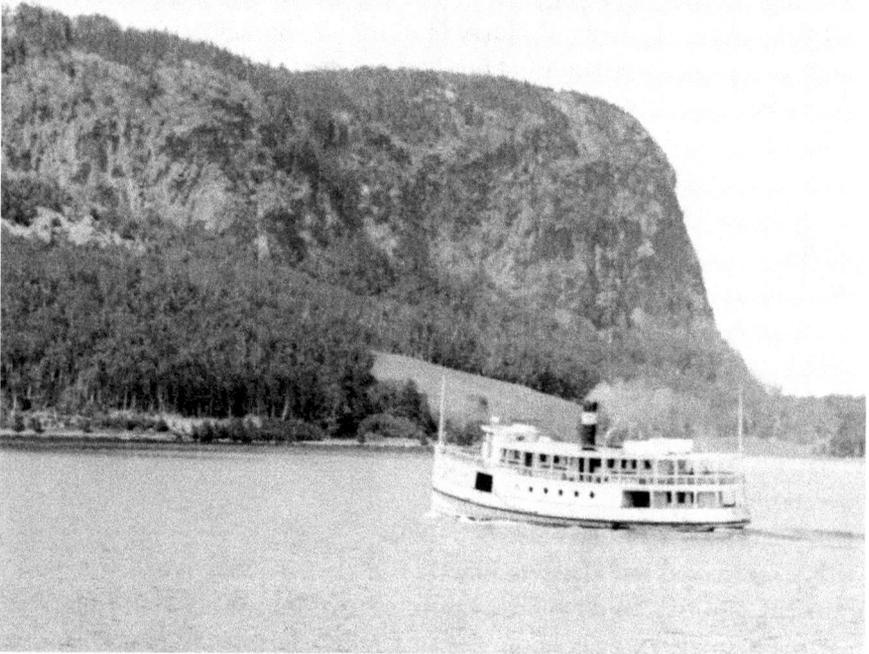

The steamship *Katahdin* on Moosehead Lake, with Mount Kineo in the background. The ship was instrumental in the recovery of the *Mac II* and bodies after the tragedy and still runs today, no date. *Collection of author James E. Benson.*

and bring it to the surface. The body was found about one hundred feet inland of the sunken vessel. Captain Lays telephoned Mayor Bent with the news, who in turn notified Mrs. Blake. Blake's was the sixth body recovered. About two hours after the discovery of Blake's body, that of Dr. Arthur F. Peterson, school physician, was brought to the surface not far from where the sheriff's body was located.[71] The bodies of three men—Dr. Frank Moberg, John Sandberg and guide Samuel Budden—were still unaccounted for. In an effort to raise the bodies of the remaining men, searchers resorted to using dynamite in the hopes that the concussion would force the bodies to the surface. So as not to

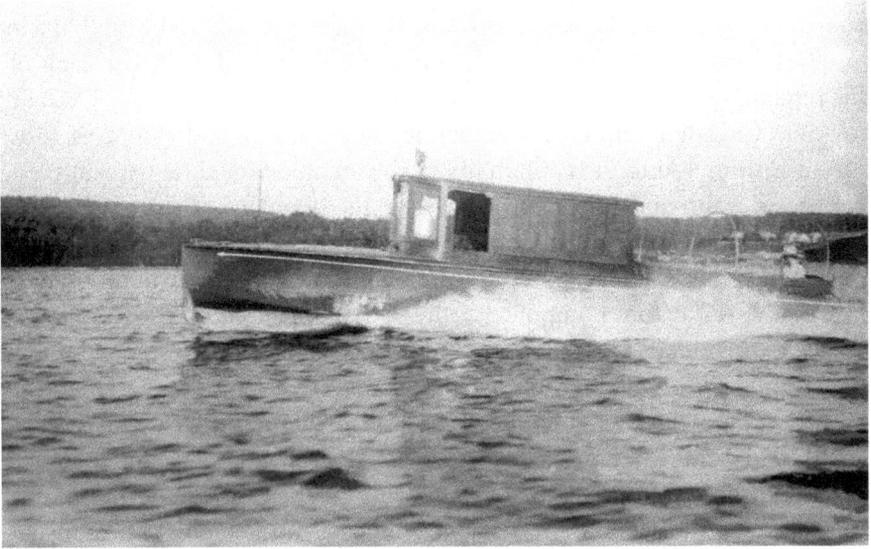

Mac II, no date. *Courtesy the Moosehead Marine Museum.*

cause any harm to the bodies, the dynamite was lowered by rope to a point about twenty feet above the lake bottom and detonated. On Thursday, May 24, three sticks of the explosive were used followed by two more on Friday, but this produced no results.[72]

With the search continuing and work back at home pressing, it became necessary for Captain Lays, Deputy Sheriff Samuel Lays and Dr. Frank French to return to Brockton. As the men left the West Outlet Camps, at home in Brockton Mayor Bent acknowledged the work of Deputy Sheriff Lays and Dr. French, saying:

> *I am sure that I can express the sentiment of every citizen of the city, when I pause to pay tribute to the spirit of self-sacrifice as exemplified by Samuel T. Lays and Dr. Frank R. French during the past 12 days. Overlooking their business interests, forsaking their family obligations, forgoing their social engagements, these two men have labored almost to a point of physical exhaustion that they might serve their fellow man. I feel that we of Brockton owe them a debt of gratitude which we can never repay.*[73]

Heavy rains slowed down the search efforts, as did the rising water level of the lake, which was already full following the spring snowmelt. On May 26, it was reported that between eight and ten thousand cubic feet of water

per second was being released into the Kennebec River.[74] Mayor Bent, in an effort to keep searchers working, offered a reward of $100 for each of the remaining bodies recovered. Meanwhile, back in Brockton, Captain Lays met with Bent and City Marshal Boyden. Officers at the police station refrained from asking the captain about the terrible ordeal he had suffered, and this restraint and respect overflowed to the populace of the city as well.

Daily, the *Brockton Enterprise* newspaper gave a brief front-page update, and each day it was the same: the search continues. The afternoon of June 5 was the first day that no update of the search appeared on the front page; however, the tragedy was still front and center, as headlines announced that First Deputy Fire Chief Frank Dickinson was selected as acting chief. On Thursday, June 7, it was announced that Mayor Bent and Dr. Frank French would be leaving that night by train for Moosehead Lake and planned to remain there for several days. According to the newspaper, the mayor wished to see the scene of the accident himself and speak with many of those involved in the search, as well as to encourage its continuance, as only three boats remained working the waters of the area.[75]

On Friday, June 8, the body of John Sandberg floated to the surface and was discovered at about 4:30 p.m. by Robert Stein as he drove his boat around the area searching for possible bodies. The body was found about a quarter mile from where the boat had been discovered. Once the body was brought ashore, the mayor and Dr. French were notified, and they identified Sandberg's body. Undertaker Harvey prepared the body for transport, and it was taken from Greenville by police inspector Allen, who was heading back to Brockton.[76] From the outset, some familiar with how nature affects submerged bodies had said it would take more than twenty days for the lake to give up the dead on its own; it had been twenty-seven in the case of Sandberg. Mayor Bent decided that he would stay at Moosehead through the weekend and would not arrive in Brockton in time for Sandberg's funeral. He directed acting mayor and president of the board of aldermen, H. Merton Snow, to take charge of arrangements as they pertained to public officials and to stand in his stead at the funeral.[77]

Two weeks later, on the afternoon of Wednesday, June 20, a body was taken from Moosehead Lake, and as of press time, identification had not been made to Mayor Bent, who was back in Brockton and awaiting a call from Frank MacKenzie of the West Outlet Camps with more information. The body was discovered floating on the surface by Maine guide Alex MacDonald and was immediately taken ashore to await the arrival of the medical examiner. This body would be identified as Maine guide and

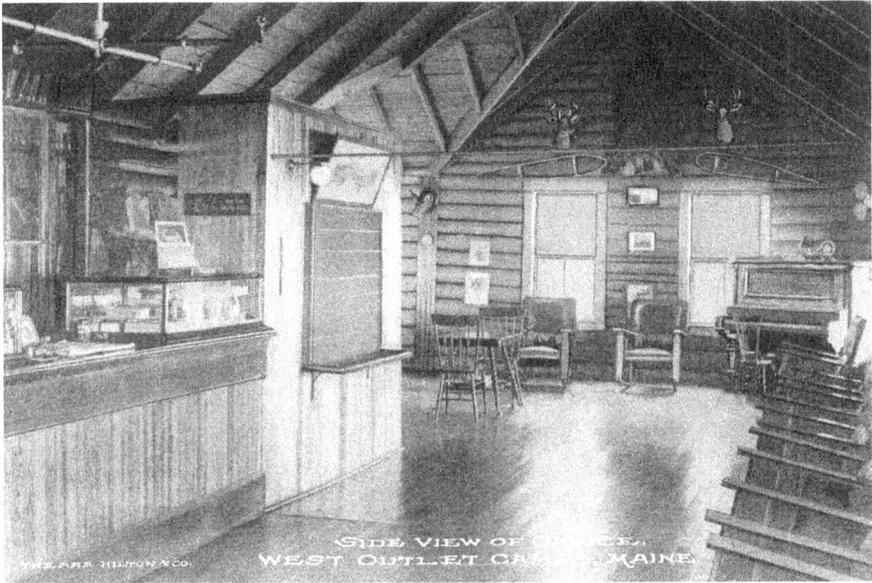

West Outlet Camp Office, circa 1916. *Collection of author James E. Benson.*

skipper of the *Mac II* Samuel Budden of Greenville.[78] At 10:00 a.m. on June 21, the lake relinquished its last victim, Dr. Frank Moberg. Both Budden and Moberg were found about 150 yards off shore in direct line between the boat and shore, indicating that they had made an effort to swim to shore. The bottom in this particular area of the lake is strewn with boulders, which had made the grappling irons ineffective.[79] Mayor Bent was notified of the discovery of Moberg's body and notified the family that the ordeal was over after a duration of thirty-nine days. Mayor Bent telegrammed the widow of Samuel Budden with a message that read, "Glad to hear that your long vigil is ended. With sincere personal regards."[80]

On June 22, the *Brockton Enterprise* ran the following editorial:

> *Thirty-nine days after the sinking of a motorboat in Moosehead Lake drowning nine Brockton men and their Maine guide, the period of suspense and watchfulness ended with the recovery of the body of Dr. Frank W. Moberg. Last to be freed from the lake's tenacious grip, it was through no fault of the city that his family had not been enabled to offer the tender and reverent rites due the dead.*
>
> *Daily since May 13, a patrol has been maintained. Recovery of the body of Dr. Moberg was by this patrol, maintained in part by the city.*

The community is familiar with the extraordinary efforts during the week following the accident, made without inquiry about cost, promoted by an impulse to accord useful citizenship a decent respect and consideration. Seven bodies were recovered within a week. Both the State of Maine and Brockton did all that was possible to reclaim the remaining three, each giving to the duty a devotion that is uncommon.

The end has come. Official acknowledgement has been made by the city, in the form of resolutions adopted by the city council this week, of its obligation to the high type of citizenship represented by the lives and work of these men. There is a bill to pay, something more than $3,000.00. A community whose sympathy was so spontaneous and sincere 39 days ago will not quibble over it.[81]

TRIBUTES

At the time of the tragedy at Moosehead, the city of Brockton was a beehive of social activity, and those ten men traveling to Maine were deeply involved in the social aspects of the community, as were several of their wives. Four of the men—Drs. Moberg and Peterson, store owner Salander and manufacturer Sandberg—were all prominent members of Brockton's Swedish community, and all resided in the city's Campello section. Upon learning of the tragedy, social engagements and activities in and around the city came to an immediate halt out of respect for those lost, and tributes came from far and wide. Among the first events to be canceled was the third annual Policeman's Ball, an event that both Captain Lays and Chief Daley had been looking forward to attending with their wives, had the fishing trip taken place in early May as planned.[82] The Brockton New England League Baseball Club had planned a parade to mark the opening of its 1928 season; the parade was canceled, and only simple opening exercises were held. Shedad Grotto, Mystic Order of Veiled Prophets of the Enchanted Realm, an organization for Master Masons, canceled its annual party, and silence reigned within the firehouses of the city except for radios bringing news flashes of the event as they came in. The Kiwanis Club held a special memorial meeting and maintained a moment of silence for fellow Kiwanian John Sandberg and all those lost at Moosehead.[83]

The *Enterprise* told of an unnamed, distinguished-looking elderly gentleman walking down the street with the newspaper in his hand, and upon meeting other men on the street, he said in a broken voice, "Terrible"

and then added, "When I left home this noon, before we knew, the little son of one of them hailed me…to say 'Daddy's gonna bring me home a fish.'"[84] *Terrible* was the word repeated over and over. Not since the Grover Shoe Factory disaster of 1905 had the people of Brockton gathered in so many places to speak in utter disbelief about what had befallen their friends and their city. The *Enterprise* ran a tribute to them, even before the bodies were recovered:

> *Thousands knew these men.*
>
> *Sheriff Earl P. Blake, courtly and chivalrous, whose manhood and honor made a county penal institution a synonym for humane treatment and the redemption of manhood. Everybody in Plymouth County counted him a friend.*
>
> *Fire Chief William F. Daley, whose code was as high, whose friends were as many, whose heroism in the face of danger made him an outstanding figure even among the valiant, whose heart was tender, whose sympathies were broad.*
>
> *Highway Commissioner G. Fred Dahlborg, 10 years in the city's service, popular and respected, survived by a wife and two young children. Every inch of him a man.*
>
> *Former Mayor Harry C. Howard, three times chief executive, a builder who contributed mightily to the progress of the city he loved and served, always to be in the forefront whenever she had a need of strong and purposeful men.*
>
> *Dr. Arthur F. Peterson, former city physician, who had ministered to the poor with a fidelity never surpassed; he too the father of two little sons.*
>
> *Dr. David Bridgwood, youngest of all, one of a family of seven, whose own flaming ambition conquered every obstacle to high rank in a profession in which he had become a specialist.*
>
> *Dr. Frank W. Moberg, another native son whose career reflected credit on parents and forebears.*
>
> *A prince had broken bread in the home of another, John Sandberg, manufacturer and upright citizen, of such unsullied democracy that he could look at royalty level-eyed, in a friendship royalty did not disdain.*
>
> *Knute S. Salander, whose integrity as much as his success as a merchant made him noteworthy.*[85]

Mrs. Barrett B. Russell, widow of the former superintendent of schools, suggested through the *Enterprise* that flags across the city be lowered to

The 1928 memorial cartoon drawn by Brockton cartoonist Wes Jenney featuring Captain James E. Lays mourning the loss of his friends at Moosehead Lake. *Collection of author James E. Benson.*

half-mast, which Mayor Bent so ordered.[86] Noting that the flagpole on Legion Parkway, in the heart of downtown Brockton, was not flying a flag due to a broken rope, a local man known as "Steeple Jim" Parker, a local missionary, asked permission of the public property department to install a new rope. With a crowd looking on, Parker completed his task in less than an hour's time.[87] The Brockton Elks Lodge canceled its meeting out of respect for the men—in particular Sheriff Blake, who was the exalted ruler of the Plymouth lodge. Members of the local Painters Union adopted resolutions in honor of those lost, and the Master Plumbers Union, of

which G. Fred Dahlborg was president, canceled its monthly meeting. The Mount Carmel Court, Massachusetts Catholic Order of Foresters, of which Chief Daley's wife, Nora, was a member, paid tribute to the chief with a letter to his wife.

Mayor Bent requested that groups within the city cancel or postpone scheduled events for several days, and he and City Marshal Boyden canceled all their personal social engagements. Mayor Bent stated, "Out of respect to the loving memory I hold for these men I am not going to keep any social engagements for some time to come and I will not go out at all except in case of dire necessity."[88] The Brockton Ministers Union met, and Rector David B. Matthews of St. Paul's Episcopal Church made a motion to express the group's deepest sympathy to the families of the deceased, three of whom were members of his congregation. Edward P. Barry, a former lieutenant governor of Massachusetts, wrote to the *Enterprise*, "The whole world mourns with Brockton and Southeastern Massachusetts over the loss of so many of its greatest and best citizens. Sheriff Blake was, I believe, the greatest and best institution director in this country, and his place cannot be filled in this generation. Please express my condolence. May God have mercy on the souls of those who have gone and may they forever rest in peace in the eternal world beyond."[89]

President Calvin Coolidge sent a message of condolence to the wife of Sheriff Blake, whom Coolidge had appointed to the position when he was governor of Massachusetts. Additionally, the Massachusetts Fire Chief's Association, of which Chief Daley was past president, canceled the meeting that it had scheduled. Congressman Louis A. Frothingham offered his condolences and aid to the mayor. The Sacred Heart Parochial School in Brockton postponed its fund drive, and the Brockton Retail Merchants' Association voted to close stores during times of the various funeral services. Charles F. Hillberg announced that the John Ericsson Lodge of the Knights of Pythias would hold a memorial service for the victims, three of whom—G. Fred Dahlborg, Dr. Frank Moberg and Dr. Arthur Peterson—were members.

Members of the Massachusetts Medical Society, of which Drs. Peterson and Bridgwood were members, held a memorial service to honor those who were lost. Meeting in Plymouth, Dr. Charles G. Miles, a close friend of both men, delivered a eulogy honoring all of those lost. In part, Miles reflected:

> *No more will we see their faces. No more will we associate with these men who had such sterling qualities. How well do I remember as city physician of Brockton during the time of the Brockton Public Market fire when Chief*

Daley was practically overcome by ammonia gas.…A man of wonderful vitality…one of the greatest firemen in the United States.

Genial and happy Earl Blake…Fred Dahlborg…happy go-lucky Fred as he was termed…always ready with a story.…Then there were Knute Salander and John Sandberg, two happy, good natured fellows, well established in their business.…And Harry Howard, good natured Harry, who made friends by the thousands and had a faculty of keeping them.… Frank Moberg who worked his way through Williston seminary, was a tenor soloist of good repute…a good standing dentist who knew his job…

I will now take up…David Bridgwood…when he was a boy his brother Fred taught him how to play the piano and also the pipe organ…during high school he spent his leisure time…teaching the younger generation how to play the piano getting 50 and 75 cents per lesson.…In the summertime he worked tending door at the James Edgar company store and in the factories of the C.A. Eaton Company and the Kimball Bros. & Sprague machine shop to earn money to help defray his future expenses through Tufts Medical College. He graduated with high honors from Tufts.…His service as a general practitioner was well known…he went away, to study the specialty of eye, ear, nose and throat…he became a star student of the eye…so much so, that he was appointed as an instructor at Harvard University.…A man of irreproachable character, high standing and one of great promise…

Like David Bridgwood, Dr. Peterson was one of the best friends I had in the city. I was the one who started him in his medical profession… that boy came into my office and wanted to talk about getting out of the shoe factory…he was an edge setter working in the making room of the Geo. E. Keith company No. 1 factory. I later learned that he was one of the fastest and best edge setters in the city.…After a hard day's work…he spent his time going to the Evening High school.…He had to leave day school at the close of his freshman year in the day school to go to work in the shoe factory.…After graduating from the Evening High school… he entered the University Maryland. He graduated cum laude.…He received appointment as intern at Mercy hospital and three months before the war broke out [World War I] he was appointed superintendent of the hospital.…He then entered the service as a lieutenant and was assigned to the tubercular section of the army. He became chairman of the examining board at Syracuse, N.Y. He afterwards was transferred to Camp Wadsworth, Spartanburg, South Carolina where he became chairman of the tuberculosis examining board at that camp. He was appointed to a captaincy and held that commission throughout his services

in the army. About three weeks before the armistice was signed, he was made divisional tuberculosis specialist for the 96th Division…

Directly after the war, he came home, and he, like Dr. Bridgwood, opened an office in the First Parish block. He was elected by the school board as school physician, which he has held up to the time of his death. He was later elected city physician…a position he held for four years. One of the monuments of his energy and thoughtfulness was the city infirmary.

During his work as city physician he noticed that the very old people who were chronically ill had no place to go.…He well knew that the Brockton hospital could not take care of old chronics. He worked hard…and with the hearty support of Mayor Bent this building was completed.…At the beginning of the year 1928 he was appointed [the] tuberculosis specialist of the Brockton health department and held the office of chief examiner for the Metropolitan Life Insurance company for the past four years.…He always took two weeks off in the spring to go fishing.

…He took particular delight in doing kind acts and deeds for his friends. He was a devoted husband to his family and father and mother. He loved his wife and children and often told to his closest friends what he intended to do for his two boys.[90]

As the recovery efforts continued in Greenville, the city of Brockton was preparing for the funerals of those who had been found and returned home. Tributes continued to be offered to the dead. The Seville Council, Knights of Columbus, memorialized Chief Daley, while the members of the Swedish Baptist Church, led by their pastor, Reverend John A. Swanson, honored them with silence and prayers. Walter Rapp of the Lions Club conducted a brief service at the club's meeting to honor fellow Lion Dr. Peterson. The Lions' quartette consisting of Chesterton S. Knight, Edward I. Reilly, Fred D. Hendrick and Ernest L. Bouldrey sang "For All the Saints." Tributes flowed from Rabbi David Goldberg and the members of Congregation Israel at a special memorial service held to honor the dead. Rabbi Goldberg began his tribute:

An unspeakably tragic thing happened last Sunday at dusk, on a picturesque lake in a picturesque state. Ten sturdy men all of our community, close friends to each other and prominent in the municipal affairs of our city were on their annual fishing trip, the trip they had been taking for years, the same lake, the same destination, and, it is said, even the same boat. But this time something untoward happened, with the lake, or with the

boat or with the skipper.…the valiant and sturdy men went down one after another, save the oldest of them, who has been providentially saved that he might tell of the horrible tale, it would seem.…"Oh, what is man?" A fire chief is apt to meet with fatal accidents, from crushed roofs and razed walls; a high sheriff is apt to meet with fatal violence from an insane criminal under his custody, while a physician is apt to contract loathsome disease himself. And even the aggressive business man is apt to meet with some traffic accident, or collapse from sheer overwork. But… to meet with so fatal an end while on vacation in a quiet region or a quiet state—oh, what is man, what is man?[91]

Rabbi A.S. Borvick of Brockton's Congregation Agudas Achim synagogue held a special memorial service for those lost, filling his synagogue to its capacity. Borvick concluded his remarks, "Every one of these men was a worthy citizen and a credit to any community, Brockton and vicinity has lost nine valuable citizens whose places will be difficult to fill."[92]

Former mayor Harry Howard was honored by Mayor Harold Bent and ten of his predecessors, as well as State Senator George M. Webber and State Representative M. Sylvia Donaldson. Reverend Arthur E. Wilson of Unity Church spoke of Howard thusly: "He was a man beloved by those who knew him, the soul of honor in his business transactions, one whose good deeds were many and unostentatiously performed. Willing to do his share in civic affairs he served as Mayor of Brockton for three terms, and always his interest was in the city's welfare and good name."[93] Chief Daley was honored by thousands gathering outside St. Patrick's Roman Catholic Church on Main Street, while fellow chiefs from all around Massachusetts and New England and as far away as New Orleans gathered within to honor a man whom the *Brockton Enterprise* described as "kind and good, generous and brave, who befriended many and was the pal to a chosen group and the centre of a happy home."

Knute Salander was proprietor of Campello's Shepard Market and a Swedish immigrant who had been in America for twenty-one years, served in the armed forces of his adopted country in World War I, had built a successful business and was known by many. Reverend John A. Swanson said of Salander, "Every heart in the city has been saddened by the loss of this man.…He was a beloved neighbor and fellow citizen. All who knew him respected and loved him. He was a good husband and kind father."[94] Reverend Dr. Peter Froeberg of the First Lutheran Evangelical Church presided at funeral services for G. Fred Dahlborg, a member of his parish.

Dr. Froeberg took for the theme of his sermon the words from I Samuel 20:18: "Thou wilt be missed because thy seat will be empty." Froeberg said, "A great calamity has befallen our otherwise calm and peaceful community...the shadow of death...layed low nine men...men who were in their prime and full of health and vigor; men of prominence in the community and successful in their respective vocations." Of Dahlborg, Froeberg continued, "We miss him, but you will miss him more, for he was your husband, your father, your son, your brother. His pleasing and genial personality won for him many friends, and he always showed a charitable spirit and brotherly kindness toward everybody....Fred Dahlborg was a kind and loving father to his children, a devout and affectionate husband and a sincere friend. He was always planning and working for the welfare and comfort of his family....He became a liberal supporter of not only his own church but of other charitable and Christian institutions as well. We will miss him."[95]

As funeral followed funeral and as the search continued with earnest effort at Moosehead Lake, the Brockton community continued to rally around the families of the departed and offered prayers and support on a daily basis. A week after the tragedy, on Sunday, May 20, many of the Protestant churches throughout Brockton honored the dead and those still missing. Reverend Dr. Horace F. Holton of the Porter Congregational Church said in part to his parishioners, "These were all good men, and true men whom any city might well be proud to number among its representative citizens and among its public officials. Now they are gone, and we are left with our long thoughts."[96] At the First Baptist Church, Reverend Thomas S. Roy began his sermon, "We have been standing deep in the shadows during the past week, and some in our community will never find their way out....While one cannot forget the economic loss to the city of such men, what is of more importance is the moral loss. For these men were all of such sterling character that we cannot afford to lose them."[97] In the heart of downtown Brockton, Reverend Roy E. Myers of the Central Methodist Episcopal Church spoke on the topic "The Life of Prayer in an Age of Science," admonishing his listeners as to the importance of prayer at times such as the city was going through.[98] Reverend A.E. Wilson of Unity Church chose for his sermon title "Life's Uncertainties," based on the verse from Proverbs that reads, "Boast not thyself of tomorrow; for thou knowest not what a day may bring forth." Wilson continued, "There is never an accident like the one at Moosehead Lake but that investigation starts in to see why it happened, why there

were no life-preservers there, or if there, why they were not accessible, why there was no small boat with oars. First, the accident happens, then the investigation, then the tightening up of laws if they are adequate, or new laws if they are needed. In this way, there is vicarious atonement. Someone pays for the better protection of others in the future."[99] Prayers, memorials and words of comfort were also offered at the First Parish Congregational Church, St. Paul's Episcopal Church, First Universalist Church and the Lincoln Congregational Church.

On Tuesday, May 22, services were held for Sheriff Earl Blake, whose body arrived in Brockton on Monday. Services for the sheriff were held in Plymouth without eulogy or music; the Massachusetts secretary of state, Frederic A. Cook, a close personal friend of the sheriff's, attended along with hundreds of law enforcement and court officers from the region. As Memorial Day neared, three bodies—those of John Sandberg, Dr. Frank Moberg and Maine guide Sam Budden—remained missing. On Friday, June 8, the body of John Sandberg was recovered from the lake. Sandberg's funeral was held on Sunday, June 10, following his body's arrival from Greenville. Although a man of prominent stature within the community, his funeral services were simple and held at his home. Throngs visited the home and lined Main Street as his cortege made its way through the city to his final resting place at Melrose Cemetery.

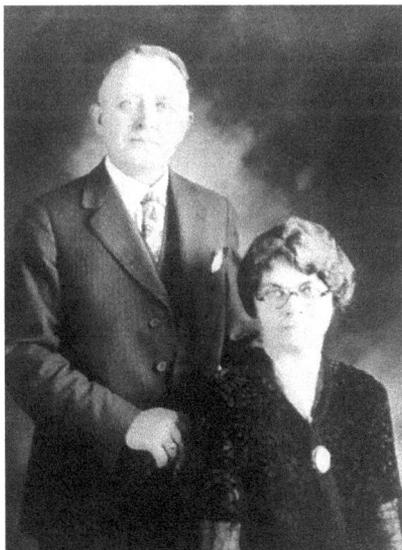

John and Alma Sandberg, circa 1920s. *Courtesy the Sandberg family.*

In resolutions passed by the city council, words of high praise honored John Sandberg, "a successful business man of the highest integrity and character, a dutiful husband whose intense devotion to his home and family, stamp him as an exemplar for the younger generations."[100]

On June 20, the body of Maine guide Sam Budden was found, and the following morning, the last of those lost, Dr. Frank Moberg, was discovered on the surface of the lake. Reverend Dr. Peter Froeberg of the First Lutheran Evangelical Church, of which Dr. Moberg was a member, presided over the funeral.

Brockton Commercial Club, no date. *Collection of author James E. Benson.*

Dr. Froeberg spoke these words: "We are now gathered to give expression of our sympathy to the relatives of our departed friend, Dr. Frank Walter Emmanuel Moberg. We are to follow to the final resting place the last found victim of the Moosehead Lake tragedy. It has been a time of anxiety and terrible suspense for his sisters and brother....Frank was dearly loved....His sunny disposition and optimistic frame of mind endeared him to all....He was successful in his chosen vocation....He was a lover of music....He was an active member of the First Lutheran church and also a member of the Lutheran Brotherhood."[101]

In tribute to Chief Daley, the Commercial Club in Brockton hosted the fire chiefs who came to the city for the funeral of Chief Daley, feeding a total of 108 persons. At its May 22, 1928 meeting, at the suggestion of President Moore that the club assume the expense of the day rather than bill the city, it was voted to notify the mayor that the club desired to "bear the cost of this day as a contribution to the memory of a worthy city official."[102]

CHAPTER 5

THE INVESTIGATION

On May 14, 1928, the *Brockton Daily Enterprise* reported that the Brockton police headquarters had received a telegram from Captain Lays that simply stated, "Accident on Moosehead Lake. Fear some are lost."[103] No details were included in this telegram from the man who would be the fishing party's only survivor. In a stupor caused by shock, fear, cold and what is today scientifically known as hypothermia, Lays tried to piece together a sometimes contradictory story as to what happened. The captain reported that the motorboat *Mac II* had capsized in stormy seas. Lays further stated that "without warning the boat started to leak and before we knew it was ready to sink." The newspaper reported, "It was easily to be told, even via telephone, that Capt. Lays was in serious condition, at least mentally. He wandered from detail to detail and could give no connected story of the affair."[104] Captain Lays reported that as the boat was about a mile below Mount Kineo, it "struck something which could have been a rock, a sunken log or even a 'growler' of ice." Lays reported that a hole was made in the bottom of the boat, causing water to pour in. He stated that the bow of the boat was pointed toward land and that everyone on board was bailing as fast as they could with whatever they could find. Lays continued to tell the reporter that the water kept coming into the boat, and in about ten minutes time, the water level had reached the ignition coil and the battery of the 145-horsepower engine, causing it to stall.[105] Without engine power, the vessel was at the mercy of the wind and waves, uncontrollable on the surface of the broad lake. The *Biddeford Daily Journal* of May 23, 1928, reported that

"[m]en who have known Moosehead Lake all their lives, who were at points on the lake on the day of the accident and men who live in Greenville, all say it was the worst sea they had ever seen on the lake and that they would not have gone out on the water in one of the bigger boats."[106]

On May 15, the *Brockton Enterprise* reported that experienced men familiar with boats and with Moosehead theorized that with the weight of the boat itself, an engine weighing in at 1,800 pounds and the weight of eleven men (some tipping the scales at 200 pounds), plus their luggage and fishing gear pounding the high seas, all caused a seam to open. To some it was a simple fact that the boat was overloaded for the conditions.[107] The theory of the boat hitting a submerged object was debunked by many, and even Captain Lays, to whom this theory was earlier attributed, said that he doubted this theory and that he had felt no shock that would have been part of hitting something on or under the water's surface. On May 18, five days after the accident, Governor Brewster ordered that an exhaustive investigation be started immediately to be certain that the *Mac II* was in compliance with all regulations required of a craft of its size and type. The Maine Public Utilities Commission indicated that the boat had been licensed on July 21, 1927, for a period of one year after being inspected by Archie E. Fairbanks, a state steamboat inspector. The license was issued after Fairbanks certified that "the boat carried 29 life preservers, a tender boat and oars."[108]

On Friday, May 19, nearly a week after the accident, the *Mac II* was raised from the depths of Moosehead Lake by the steamer *Katahdin* after a diver hooked a chain to the bow and winched it upward. The *Katahdin* had been at work since the accident took place, pulling chains and grappling

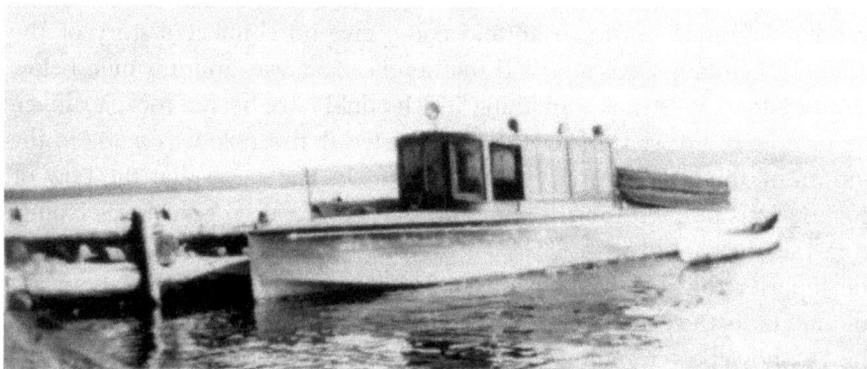

Mac II, no date. *Courtesy the Moosehead Historical Society.*

irons and tending a scow that served as a working platform for divers. The *Katahdin*'s owners, the Coburn Steamboat Company, and its vice-president and treasurer, C.F. Woodward, placed the vessel at the disposal of the search party, with the company absorbing the $200-per-day cost of operating the vessel, not including the lost revenue of hauling massive rafts of logs down the lake. The *Mac II* was brought nearly to the surface and towed to Kineo, where it was pulled from the water on the boat railway and drained. It was then refloated and towed to the West Outlet Camps on Saturday morning for inspection by Archie Fairbanks and Frank A. Dolloff of Augusta, the assistant inspector of utilities for the State of Maine. The *Brockton Enterprise* reported on May 19 that as the boat sat at West Outlet Camps, there was no indication that ten men had lost their lives on board. It was reported that even the glass in the windows of the superstructure was still intact.[109] *Enterprise* reporter Thomas E. Sullivan was present for the inspection, and inspector Fairbanks gave Sullivan the following statement:

I find nothing wrong with the boat. The seams are tight and I find no hole in the boat's bottom. It seems possible that the automatic pump failed to work. That is likely because there is delicate mechanism in it that might have been put out of order through fouling of a small wire under the floor boards. Often waste material works into pumps disabling them.[110]

At the insistence of Governor Brewster, a second probe was conducted on the morning of May 22 and involved county attorney Clarke from the Attorney General's Office, inspectors Fairbanks and Dolloff, Deputy Sheriff Rogers of Greenville, boat owner J. Fred Sawyer, survivor Captain James Lays and Dr. F.R. French of Brockton. On May 29, Fairbanks and Dolloff released the official report of their investigation, the text of which follows:

On May 13, 1928, the boat left Sawyer's Wharf about 4:40 P.M. headed for R.F. Spinney's camp at Tomhegan, a distance of approximately 37 miles. After proceeding about 16 miles, one of the passengers, James E. Lays observed water on top of the floor in the rear cockpit. He called the attention of operator Budden to the fact who immediately came back and proceeded to either open or clear the automatic bilge pump the outlet of which is through the keel of the boat. Then he returned to the bow of the boat after which Captain Lays said the water lowered out of sight below the floor of the boat.

In a very short period of time water again appeared and increased rapidly. He again called the attention of the operator, who proceeded to affix a hand bilge pump through a deck plate on the starboard side of the boat and about six inches above the water level of the lake, the pump to his [Lays's] remembrance being operated by one of the passengers.

Water continued to rise and the engine went dead thus losing control of the boat, and it swung into the trough of the sea. At that time life preservers were distributed and the boat reeled and took in some water. Captain Lays had at this time mounted the stern deck and throwing off his coat, seized a piece of board supposed to be the back of a seat. Water having risen about half way to his knees, he jumped overboard and finally reached shore. At the time he jumped overboard it was the last he saw of the boat or any person who was on the boat. He did, however, hear them shout several times.

This boat was overhauled and painted during the winter and had been launched about May 12 and had remained in the water, this trip being the first attempted for this season. During the time that the boat was lying in the water it was looked after by the owner [J. Fred Sawyer] and Operator Budden, each having used a hand bilge pump at times. In using the pump the deck plate cap located on the starboard side of the boat had to be removed so that connection of the pump might be made through the side of the boat. There is no evidence as to the amount of water which was in the boat at the beginning of this trip.

When the boat was first launched there would naturally be some water leak in around the stuffing box, and a possibility that in a boat lying at anchor some water might enter through the automatic bailer. It is, however, evident that some water was in the boat at the time of starting and possibly more than any one had any idea of. The automatic bailer is supposed to work at a speed of 10 miles per hour or over, but should any obstruction interfere in the operation of this bailer there is a possibility that the valve might be held open. If the speed was decreased for any reason, water might flow into the boat, and if the cap of the deck plate was not in its place more or less water would enter the boat, and this would be noticeable to the occupants of the boat on account of a small door made into the lining of the boat and which had to be opened to see or reach the deck plate.

A continuous rapid rising of the water in the boat might have reminded the operator that water was flowing through the deck plate and he, finding the cap off, replaced it, in which condition it was found after the boat was raised. After a certain depth of water got into the boat it would reach the magneto and put it out of commission.

There is also a switch located on the forward end of the housing over the engine which by being accidentally opened would shut off the power, thus leaving no control over the boat, and she would naturally swing into the trough of the sea, giving a chance for the waves to break over.

At this time the passengers would become more or less excited and in throwing their weight to one side or the other, would cause the boat to take in water over the top, fill and sink. Upon examination the boat was found to be sound and intact. After our [Fairbanks & Dolloff] investigation, we believe that the above explanation gives the cause of the sinking of the boat.

The report concluded:

The persons drowned were Samuel Budden of Greenville, the operator of the boat, William F. Daley, Dr. Arthur F. Peterson, Dr. David Bridgwood, John Sandberg, Fred Dahlborg, Dr. Frank Moberg, Harry C. Howard and Knute Salander of Brockton, Mass., and Earl P. Blake of Plymouth, Mass., Capt. Lays of the Brockton Police Department was the only survivor of the party. [111]

View from MacKenzie's West Outlet Camp across Moosehead Lake to Mount Kineo, no date. *Collection of author James E. Benson.*

Apparently unsatisfied with the investigations so far conducted, the Maine Public Utilities Commission engaged the services of Commander Harold E. Saunders and Commander E.R. Norton of the navy yard at Kittery, Maine. Saunders had been heavily involved in the raising of the USS *S-4* submarine earlier in 1928 following its December 1927 sinking. Saunders and Norton would be working with Fairbanks and Dolloff on their investigation.[112] Newspaper articles do not mention any results of this investigation, and no copy of an investigative report can be found that changes any part of the findings as reported by inspectors Fairbanks and Dolloff.

On May 24, even before the last body was recovered and the investigation completed, the *Portland Press Herald* ran an editorial that ended, "After all is said and done, there seems no more reasonable explanation of the disaster than it was a dangerously rough day, that the passengers became panic stricken, and that the laws of gravitation caused the inevitable....The Mac II has covered more than 100,000 miles on Moosehead Lake in the past five years and without a serious mishap."[113] The *Mac II* was repaired and renamed the *Wee* and would serve the people of and the visitors to Moosehead Lake for many more years.

By the end of June, the recovery of all of those lost, the raising of the motor boat and the investigation completed gave bittersweet closure to the families left grieving in Greenville, Brockton and Plymouth.

"TEN DROWN, ONE SURVIVOR"

DR. DAVID BRIDGWOOD

Dr. David Bridgwood was born in Brockton on August 19, 1894. He was the fifth of ten children born to William F. and Fannie (Smithyman) Bridgwood. In addition to his parents, he was survived by his six brothers and three sisters. A graduate of Brockton High School in 1913, Bridgwood attended Tufts Medical College. After graduating in 1917, he went on to intern at Worcester City Hospital in Worcester, Massachusetts (Worcester City Hospital was established in 1871 and closed in 1995). During World War I, Bridgwood was commissioned as a lieutenant in the Navy Medical Corps on September 21, 1918, and stationed at the Naval Dispensary in New London, Connecticut. Bridgwood returned to Brockton in 1920 to work at Brockton Hospital, where he remained until 1925, when he returned to school to specialize as an oculist. From September 1925 to June 1926, Bridgwood interned at Massachusetts Eye and Ear Infirmary, after which he returned to Brockton.[114]

The youngest of the ill-fated party, Bridgwood still lived at home. The day before his funeral, his mother told a reporter from the *Brockton Enterprise* that the trip was the first he had planned since completing his medical training. However, she also recalled she had a bad feeling about the trip. As the party was leaving early on Mother's Day, Bridgwood gave his mother money for flowers the night before he left and also presented her with presents for her birthday the coming week, as he would be away. The birthday gifts included

money, a coat and a few small "trinkets." He also gave her a copy of his will, which caused her to say to her son, "You must not go Davey. I have a feeling that something may happen." Bridgwood replied, "Why mother, you don't mean I shouldn't go; it's the greatest party that I ever planned and I've banked on it so long, but if it is going to cause you a moment's pain or worry, I'll stay back." She relented: "No Davey, I won't spoil your good time. Perhaps I am over-anxious about you." His response to her worry was, "Now mother, don't worry over that [the will], nothing is going to happen; and besides, you know it's always best to have your affairs in order at all times." But something did happen, and Fannie Bridgwood's fears became a reality when her son's remains were recovered on Wednesday, May 16, 1928, her sixty-third birthday.[115]

Bridgwood's body was the first of the ten victims found. A full military funeral service was scheduled for Sunday, May 20, at 3:00 p.m. at St. Paul's Episcopal Church on Pleasant Street in Brockton, where Bridgwood was a member. In addition to being a popular physician, Bridgwood was also well known in musical circles. In addition to writing the music for the class ode in 1913, he also had been an organist at St. Paul's Episcopal Church and First Universalist Church. "Dave," to all who knew him best, laid in state at his parents' home at 424 Prospect Street until noon the day of the funeral, and many friends and patients paid their respects. The *Enterprise* reported the following tribute paid by an elderly patient:

> *Her eyes once sightless but now able to see through his deft ministrations, a little old lady, her limbs slowed by age...knocked at the door of the home of Mr. and Mrs. William F. Bridgwood where she asked to be allowed to view the body of Dr. David Bridgwood....Invited in, for several minutes she gazed upon him...then after her lips had finished muttering a silent prayer, she turned to the popular specialist's parents and said between sobs: "I can sympathize with you in your trial, but I know there are a good many more who feel his great personal loss. I knew what a man he was. For years cataracts in my eyes shut out the joy and gladness of life. He treated me and I could see again. See only to come here and find him gone. What a pity for you and mankind."[116]*

Members of the Brockton Post of the American Legion accorded Dr. Bridgwood full military honors, assisted by Veterans of Foreign Wars and Spanish-American War Veterans. Nearly one hundred World War I veterans marched as a delegation from the Legion rooms on Main Street to

the Bridgwood home on Prospect Street and then escorted the body from the home to St. Paul's Church on Pleasant Street. Friends filled the church to overflowing. The coffin was wheeled up the aisle by six men in uniform, doctors all but one. Reverend David B. Matthews, STD, rector of St. Paul's Episcopal Church, offered a eulogy that praised the doctor's skill and character. Reverend Matthews noted that "everyone who had dealings with him particularly after he became a physician of large ability had commendable things to say about him. He was thorough, skillful, genuine and sympathetic."[117]

After the service, the open casket was brought to the vestibule of the church for one last look by mourners before it was closed and over it the colors draped. The

Dr. David Bridgwood, no date. *Courtesy the Brockton Historical Society.*

casket was then placed on the caisson, and six horses carried it through the rain the three miles to Melrose Cemetery along Pleasant to Pearl Street. The downpour worsened as the casket was laid on the grave. Prayers were then offered at the grave site by the rector and Chaplain Woodbury S. Stowell. Orders were given, and eight guns fired three volleys as the casket was lowered in the grave. A bugle sounded, and then it was over. The time was 6:10 p.m., the hour when exactly a week before Moosehead Lake had claimed its victims.[118]

The will Dr. Bridgwood left with his mother would be filed in probate court on May 25. Created in January 1924, the will was witnessed by fellow drowning victim Dr. Arthur F. Peterson. Details released in the *Daily Boston Globe* included that the will left $2,000 in trust to his mother, the principal and interest to be applied toward the education of his brother George R. Bridgwood. A like amount was listed for his sister May I. Bridgwood. His two other sisters, Matilda and Elizabeth, were to both receive $500. Any remaining funds were left to his mother.[119]

KNUTE SALANDER

Knute Sigfrid Salander was born on February 15, 1887. He immigrated to Brockton from the port of Gothenburg, Sweden (located approximately one thousand kilometers southwest of his birthplace and residence of Skelletea in northeast Sweden). Sponsored by his brother, John G. Salander, a shoe worker in Brockton who came to the United States in 1890, Knute arrived in Boston on November 11, 1906, at the age of nineteen. On October 26, 1909, he applied for citizenship, listing his occupation as a clerk, and was naturalized a U.S. citizen on January 15, 1912.[120]

Until his marriage to Ebba Swanson in 1917, Salander lived with his brother on Menlo Street in Brockton, continuing work as a store clerk at the local grocery store Anderson and Nilson. After serving in World War I, he returned to Brockton, where he and his partner, Edwin Brogren, opened Shepard Market. Located on Main Street in the Campello area (Swedish section) of Brockton, the market was popular and operated until about 1966. As co-owner, Knute Salander was a popular businessman and well respected in the community. Passport records show that he and his wife returned to Sweden for a trip in the early 1920s before beginning their family. On August

Exterior of Anderson and Nilson Market, circa 1910s. *Collection of author James E. Benson.*

23, 1925, the couple welcomed a daughter, Virginia Ebba, and two years later, their son, Donald Kenneth, was born on April 14. It was this family Knute left on that Sunday for his annual fishing trip with the "boys"—a trip from which he would not return, leaving his widow to continue his business and raise his children without him.

Salander's body was found at 10:00 a.m. on Thursday, May 17. Knute Salander's funeral was scheduled for Sunday, May 20, at 1:00 p.m. at Sampson Funeral Home. Viewing hours were held Saturday afternoon and evening, as well as Sunday until the hour of the funeral. One of four funerals held that day, hundreds gathered to pay a final tribute to the popular businessman, including Mayor Bent and City Clerk Sullivan, who represented the city government. Also present was a detail of officers of the Brockton Post of

SHEPARD MARKET CO.
GROCERIES, MEATS, PROVISIONS
838-840 Main St. Tel. 4350

Shepard Market ad, May 1928. *Courtesy the First Evangelical Lutheran Church, Brockton.*

Interior of Shepard Market, no date. *From left to right:* Salander's partner, Edwin Brogren; Everett Hedin; and Alan Johnson. *Reproduced with permission from* Swedes of Greater Brockton, *by James E. Benson and Lloyd F. Thompson.*

Knute and Ebba Salander, no date. *Courtesy Todd von Hoffmann.*

the American Legion. As a veteran of World War I, Salander was entitled to a military funeral, but the family requested these rites be omitted in favor of the simple spreading of the flag over the casket.[121] Reverend John A. Swanson, pastor of the Swedish Baptist Church, officiated at the service.

In his eulogy, Reverend Swanson described Salander as a beloved neighbor and fellow citizen. "Those who knew him respected him and loved him.... He was a good husband and father." After the funeral, a brief committal ceremony was held at Melrose Cemetery.[122] His wife would move to Taunton in the 1940s and open a sweet shop called the Swedish Coffee Shop. Ebba Salander died in September 1969. Their children would grow up and marry and raise families of their own outside Brockton. Daughter Virginia "Gini" married Bernard von Hoffman and lived in New Jersey and Hilton Head, South Carolina, where she died in 2010. Donald died in 1997, having resided many years in East Sandwich, Massachusetts.

CHIEF WILLIAM F. DALEY

Born in Boston on April 19, 1873, William F. Daley was the son of Dennis A. and Katherine (Kerrigan) Daley. In 1884, the family moved to Brockton, where Dennis went to work in one of the city's many shoe factories. That same year, at the age of eleven, William left public school and followed his father into the shoe industry, becoming a shoe crimper at the Preston B. Keith Shoe Company in Brockton. He continued in the position until he became a paid fireman on August 13, 1898. His work with the fire department, however, had begun six years earlier in December 1892, when, at the age of nineteen, he volunteered as a "call man." In 1894, he was promoted to call lieutenant and in 1895 became a call captain. His first assignment as a paid fireman was as a hoseman with Engine Company No. 2. On February 24, 1903, he was promoted to captain and, two years later, responded to the Grover Factory Fire, the deadliest fire in the city of Brockton's history.[123] The fire occurred on March 20, 1905, when a boiler in the basement of the R.B. Grover Shoe Factory exploded, leveling the building, killing 56 people and injuring 150 more.

On February 2, 1907, Daley was promoted to assistant chief of the department. Two years later, he was placed in command of the newly formed Squad A, a specially trained company that had the first motorized piece of equipment in the city. Known as the "Flying Squadron," it was ordered to respond to all "Bell Alarms" (alarms for a fire) and to assist the then horse-drawn steamer Engine Companies and horse-drawn ladder companies. Still in existence today, Brockton's Squad A continues the tradition and assignment to respond to all "Bell Alarms."[124]

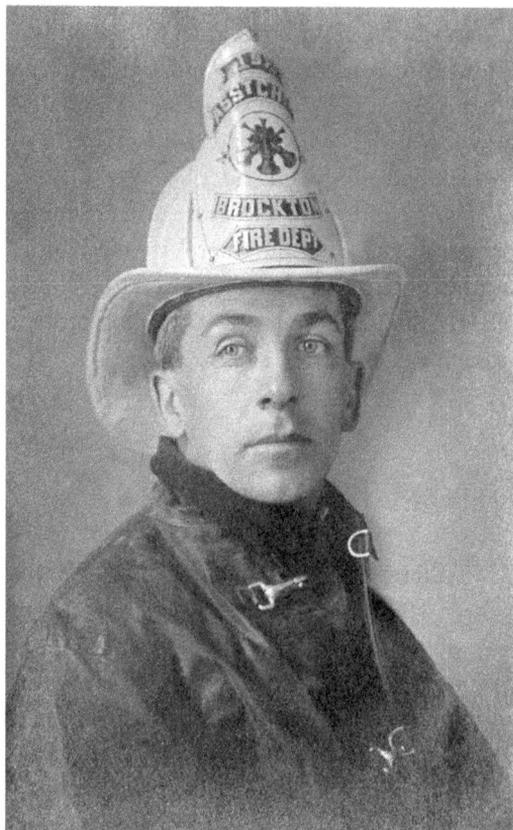

Left: Fire Chief William F. Daley, 1915, when he was still first assistant chief. *Collection of author James E. Benson.*

Below: Brockton Fire Department Squad A, with Assistant Chief William Daley sitting in the passenger seat, 1910. *Collection of author James E. Benson.*

On May 22, 1916, Daley was appointed by Mayor John S. Burbank as the second permanent fire chief of the city. He replaced Chief Harry Marston, who had passed away on May 18, 1916, at the age of fifty-four from heart problems. Marston had held the position since October 4, 1892, having been appointed by Mayor Edward Keith, the same year Daley joined as a volunteer. Chief Daley had already been in charge of the department for two years due to Chief Marston's failing health and quickly became one of the most respected chiefs in the area, bringing efficiency to the department and adopting the latest innovations.[125] A good, kind and gentle man but a strict task master and disciplinarian when necessary, Daley was known to fight "to the last ditch for his men."[126] He proved this many times after becoming chief, often outside the city offering mutual aid to surrounding towns. On May 11, 1919, he led his men in assisting Stoughton in fighting a fire at the Swan Block that resulted in $80,000 damage. On December 10, 1924, Daley and his men responded to a fire at the Bridgewater Normal School that destroyed three of the college's buildings, more than half of the campus at the time (a $1 million loss). During the fire, he received one of his most serious injuries while a member of the department: a fractured leg. Daley was injured when a platform collapsed under him. However, this was not his first injury. He punctured the balls of his feet after stepping on nails at a general alarm fire at Brockton Public Market on March 1, 1916, just before being named chief, and received painful lacerations to his hand at a fire that threatened the Bay State Block on Centre Street on January 9, 1924.[127]

His tenure as chief saw a decrease in fires and damage but also the death of two firemen in the line of duty. On May 18, 1923, Combination 2 crashed into a pole on Plain Street while responding to a call. The truck overturned, pinning fireman Herman J. Coudy and driver Charles A. Daley under it. Coudy was killed instantly, but Daley was rescued only to die the following day. Captain William Putnam and hoseman Clifford Newton were thrown clear of the vehicle but suffered serious injuries. But the chief continued to work, even though Charles Daley was his younger brother.[128] The next loss of life of Brockton firefighters in the line of duty would not be until March 10, 1941, when thirteen firefighters lost their lives when the roof collapsed at the Strand Theatre Fire.

In 1900, Daley married Nora A. Quill of Brockton, the daughter of John and Mary (Dineen) Quill. The couple made their home at 210 Highland Street in Brockton and had three children: William F. Jr., born on February 16, 1902; Marie A., born on March 12, 1909; and Clement E., born on

April 15, 1917. One newspaper described him as living by the watchword "on call," a man who practiced a twenty-four-hour schedule with a fire alarm signal bell connected to the fire station in his home to rouse him from bed, allowing him to rarely miss a fire.[129] However, in honor of a request of the chief to his wife in the past to have "the funeral as near to that of a man who had lived as private life as possible," his body was "laid in the casket in a plain business suit."[130]

Brockton said its final goodbye to Chief Daley on Monday, May 21, 1928. The funeral took place at St. Patrick's Catholic Church on Main Street in Brockton, with interment at Calvary Cemetery. At 9:00 a.m., those who knew him best gathered at Daley's home for one final goodbye and word of sympathy to his widow and children. When it was time for the procession, it took six open automobiles to fit the flowers that had been sent in tribute. "As the cortege passed through the streets stores and offices were closed and curtains drawn as the procession passed." Assistant Chiefs Frank Dickinson and Murphy acted as bearers while all members of second platoon, off duty at the time of the funeral, escorted their chief to the church. Behind them were one hundred fire chiefs from within fifty miles of Brockton, then club associates, city and state officials and representatives from other organizations, all paying tribute to the beloved chief.[131]

At the church, thousands gathered both inside and out for the solemn Catholic mass of requiem, celebrated by Reverend Irving L. Gifford. Even before the mass concluded, automobiles lined North Cary Street and at the entrance of Calvary Cemetery, while hundreds assembled at the grave site waiting for the procession from the church. Committal prayers were read by Reverend Walter H. Gill. Carrying out the chief's wishes, the custom of tolling fire bells during the funeral services of a chief of the fire department was omitted. There was also no use of fire apparatus in the funeral procession.[132]

G. FRED DAHLBORG

In Brockton, the Dahlborg name was well known in the 1920s. Charles F. Dahlborg was a successful businessman with a contracting, heating, plumbing and roofing establishment, C.F. Dahlborg and Sons, known as one of the oldest and most substantial in the Brockton area. In fact, 973–81 Main Street was referred to as the "Dahlborg block." C.F. Dahlborg

Dahlborg family, circa 1900. *From left to right*: Ida, Charles F., Carl Emil, Lillian, Laura, G. Fred and Edward. *Courtesy Edward N. Dahlborg*

and his wife, Laura Glass, both Swedish immigrants, had six children. Their fourth child and third son, Gustaf Frederick, was born on December 13, 1888. He would join his father in business along with his brothers, learning the trade and becoming a master plumber. Through the years, as he continued to work with his father, G. Fred proved "successful in both the managerial and subordinate parts of the business." In 1926, G. Fred joined his two brothers Carl Emil and Edward in purchasing the firm, which included an undertaking business, operated by Carl Emil, who served as the undertaker for most of the victims of the tragedy, including his brother.[133]

In June 1917, G. Fred listed his occupation as a contractor on his World War I draft registration card. He would not serve in the military, claiming an exemption from the draft due to "sciatic rheumatism."[134] In addition to working with his father, G. Fred would follow his brother Edward into politics. Edward N. Dahlborg, a lawyer, was elected to several terms in the Massachusetts Senate in the late 1910s and 1920s. Affiliated with the Republican Party, G. Fred served from 1919 to 1920 on the board of

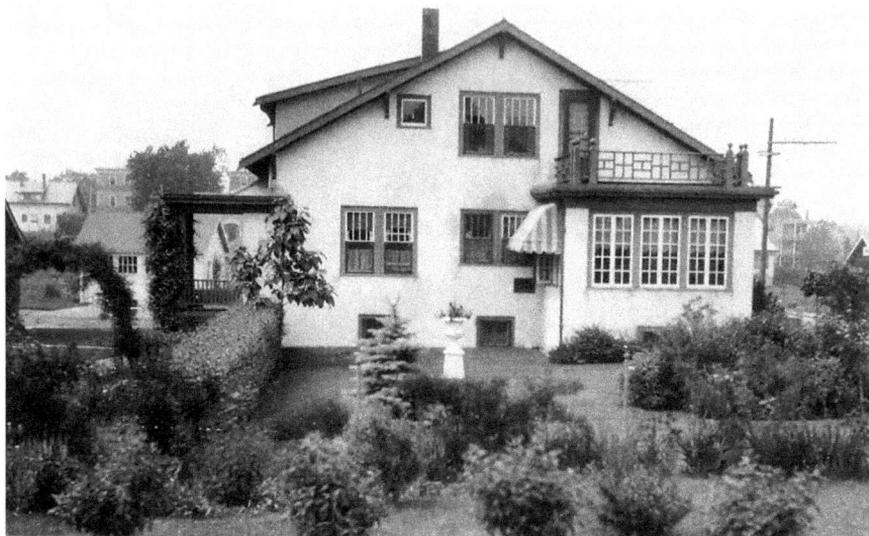

Dahlborg family home, circa 1920s. *Courtesy Dorothy Dahlborg Kendrew.*

Dahlborg family, circa 1920s. *Courtesy Dorothy Dahlborg Kendrew.*

aldermen. In 1922, he was appointed to the highway commission and, in 1926, became chairman. It was this position he held at the time of his death.

In addition to his business and political life, G. Fred was also a family man. He married Hazel Augusta Wilmot of North Easton on June 20, 1913. The couple had two daughters: Emily, born on March 19, 1915, and Dorothy, born on September 3, 1923. Furthermore, G. Fred was involved in many fraternal organizations, including the St. George Masonic Lodge, Vega Club, Vasa Order, Knights of Pythias, Brockton Chamber of Commerce and the Master Plumbers Association, of which he was president. In 1921, he also served as the secretary of the Building Trades Association in Brockton.[135]

G. Fred's body was located on Thursday, May 16. Hundreds gathered at the Dahlborg's home at 69 Echo Street on Sunday, May 20, at noon for his funeral service. Representatives from city government and the business community along with employees from the Highway Commission and friends and family came to pay their respects. Reverend Peter Froeberg, pastor the First Lutheran Church, conducted the funeral and described Dahlborg as having a "pleasing and genial personality that won him many friends. A man who showed a charitable spirit and brotherly kindness toward everybody." After the eulogy, the funeral procession moved through the city to Melrose Cemetery, where Reverend Froeberg conducted the final committal service.[136] Hazel Dahlborg would raise the couple's two daughters, getting a job at city hall. She died in 1961 at the age of sixty-seven.

Mayor Harry C. Howard

Harry Clough Howard was born in Brockton on April 23, 1877, to George Howard and Alice M. Clough. After finishing public education in Brockton, he enrolled in Bryant and Stratton Business College at the school's Boston location, which was acquired by Newbury Junior College in 1975. After graduation, he became an apprentice to the brick mason's trade under his father. Upon completing his apprenticeship, he was employed by his father and became well known as a brick mason and contractor. In 1905, George Howard and Sons was incorporated, and Harry was made treasurer of the company, while his brother Preston was named secretary. The company was very successful and extensively engaged in all kinds of construction and building, from excavation to

the finished structure. Some of the many projects in Brockton included First Baptist Church (1910), James Edgar's Company Block, Home National Bank Building (1911) and the Bay State Block, among others. Massachusetts projects outside Brockton included Whitman Town Hall and the State Soldiers Home Hospital at Chelsea. The company was also responsible for the Masonic Hall in Madison, New Jersey, in addition to library buildings both in and outside Massachusetts.[137]

Continuing a long family tradition of military service, during the Civil War, Harry's father, George Howard, enlisted in Company F of the Sixth Massachusetts Infantry at the age of fifteen but was mustered out after one hundred days. George's great-grandfather Nathan Howard joined the Massachusetts militia at West Bridgewater in 1776, serving as a sergeant under Captain John Ames. A dedicated Republican, George's "retiring disposition and domestic tastes" kept him from seeking public office. Like his father, Harry Howard was also a firm "believer in the principles of the Republican Party," but unlike his father, he would not join the military but would take an active interest in the political affairs of the city. In 1908 and 1909, he served as a member of the city's board of aldermen (serving as chair in 1909) from Ward 2. During that time, he chaired the committees on highways, public property, fire and buildings. He was also a member of the committees on street railways and police.

Image of First Baptist Church, built by Harry Howard and Sons, 1910. *Collection of author James E. Benson.*

This Church Built by
GEO. HOWARD & SONS CO.
GENERAL CONTRACTORS
BROCKTON, MASSACHUSETTS

Advertisement for George Howard and Sons Construction Company in the dedication booklet for First Baptist Church, Brockton, Massachusetts, 1910. *Collection of author James E. Benson.*

In 1910, Harry Howard was chosen as the Republican nominee for office of mayor and won by a substantial majority. He served one-year terms during 1911 and 1912 and was the youngest mayor in the state of Massachusetts. In 1912, he was defeated by Charles Hickey but reelected in 1913 for one more one-year term in 1914. One of his more notable first acts as mayor was an effort to stop profanity in the city of Brockton. In May 1911, he told the *Daily Boston Globe* that he was "emphatically insistent that the young and middle-aged women who walk the main streets shall not be subjected to insults and annoyances from young men who frequently gather at the street corners or in doorways."[138] After leaving office in 1914, he returned to his business but also remained active in city enterprises, serving as president of the Brockton Chamber of Commerce from 1915 to 1916 and a member of the city's Commercial Club and Knights of Pythias. He was also a member of the Sons of the American Revolution, having joined in 1924, citing his great-great-grandfather Nathan Howard's service.[139]

Howard's body was the fifth to be recovered, found by guides Lowell and Green on Friday, May 18, not far from where the body of Chief Daley was located. Funeral arrangements were announced the following day after the return of his brother Preston, who had traveled to Maine to aid with the recovery. Upon return to Brockton, undertakers Tirrell and Russ took charge of the body and brought it to Howard's home at 187 Moraine Street. The body would lie in state, and friends were invited to call between the hours of 11:00 a.m. and 1:00 p.m., Sunday, May 20. Funeral services were held later that day at the home and were private. These arrangements had been the wish of Howard, who had expressed his opinion for a private funeral at funerals he had attended in the past.

Attendance included family and current members of city government, including Mayor Bent and all living ex-mayors, including Charles Williamson, David Battles, John S. Kent, Stewart B. McLeod, Roger Keith, Charles

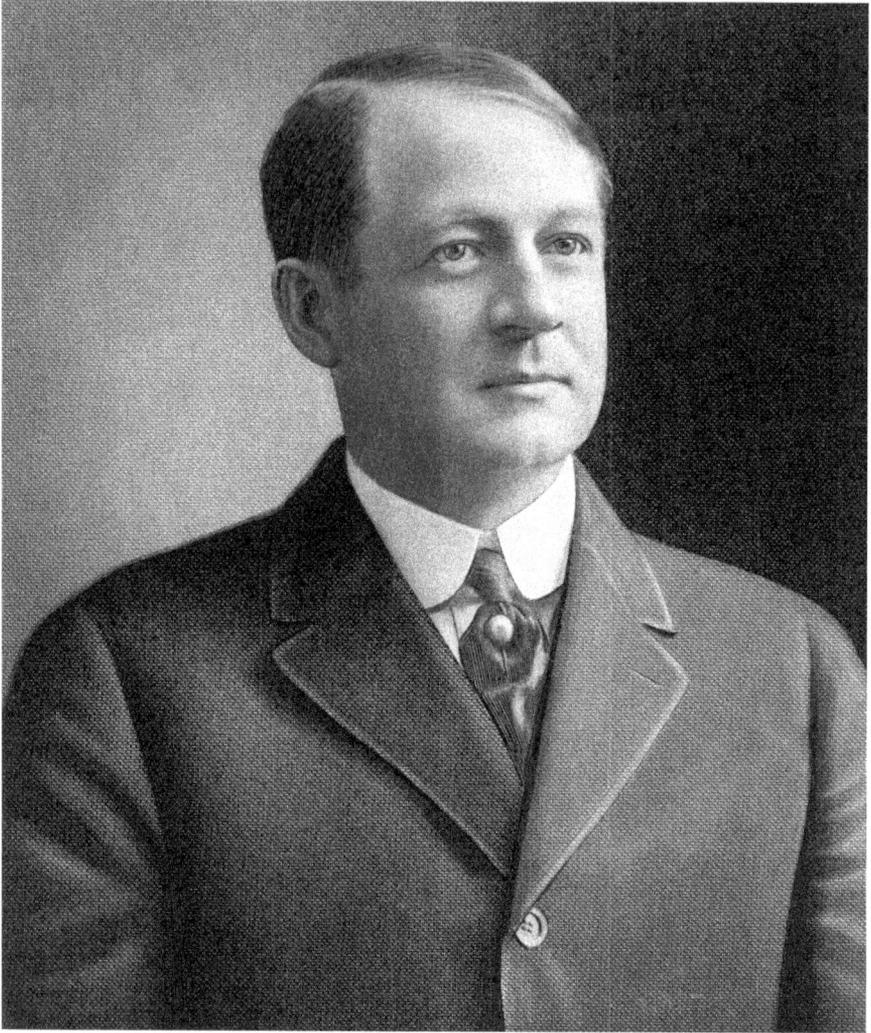

Mayor Harry C. Howard, no date. *Collection of author James E. Benson.*

Hickey, John Burbank, William A. Manning and William L. Gleason. Also present were State Senator George Webber and State Representative M. Sylvia Donaldson, as were officers of Massasoit Lodge, IOOF and Damocles Lodge, Knights of Pythias. Services were conducted by Reverend Arthur Wilson of Unity Church, whose eulogy was a tribute to a man devoted to the city of Brockton.[140] In addition to his parents and siblings, Howard left behind his wife of thirty years, Alice G. Carver. The couple, married on May

4, 1898, had just celebrated their thirtieth wedding anniversary the week before the tragedy. The couple's only child, George Marston, born on May 27, 1901, died of tuberculosis on March 26, 1904, two months shy of his third birthday. Alice Howard died on December 29, 1966, and is buried with her husband and son at Melrose Cemetery.

Sheriff Earl P. Blake

Earl Percy Blake was born in Brockton on September 22, 1873, to Edwin H. and Elenora Vinton (Young) Blake. After completing grammar and high school in Brockton, he enrolled at Bryant and Stratton Business College's Boston location. Upon graduation in 1895, he took a job in the Brockton offices of the New York Express Company. In 1898, he accepted a position as the private secretary to Mr. Miller of the O.A. Miller Treeing Company of Brockton but worked from the company's Boston office. That same year, on October 2, he married Louise Porter of Brockton.

Making their home in Brockton, the couple had no children. In 1901, at the age of twenty-eight, Blake was appointed by his father-in-law to fill the unexpired term of Deputy Sheriff Frank Porter. A year later, he was elected as deputy sheriff and served until 1911, when he was appointed a special sheriff. Following the death of his father-in-law, Sheriff Harry Porter, on January 3, 1919, Blake was appointed by then Massachusetts Governor Calvin Coolidge as Plymouth County sheriff. When Porter's term expired in 1926, Blake was elected to a full term, beginning on January 1, 1927.

Prior to World War I, Blake was a member of the Brockton Business and Professional Men's Military Company, which drilled at the Brockton Armory, and served as captain of that unit. In 1917, the company joined with the National Rifle Association to enable members to take advantage of the availability of rifles and ammunition obtainable from that group. Similar groups from throughout Massachusetts came together and founded the Massachusetts School of Military Instruction, of which Blake was elected president. The group was then able to receive instruction from the National Guard and receive equipment from the state. The combined companies would eventually form the nucleus of the Massachusetts State Guard, in which Blake was commissioned a captain of Company I of Brockton. When his company was assigned to the Fourteenth Infantry of the Massachusetts State Guard, Blake was commissioned a major and assigned to the Third

Battalion of the regiment, with which he remained for the entirety of the war. In 1919 and 1920, Blake served on the military staff of Governor Calvin Coolidge.[141]

Blake was a popular sheriff. His kind and unaffected personality made him hundreds of friends. As sheriff, he believed that the unfortunate who came within his jurisdiction were to be pitied rather than censured, and his handling of the House of Correction at Plymouth was a model for other institutions to follow. Blake made national news on June 23, 1924, when he escorted Charles Ponzi from Plymouth County Jail to the Suffolk County Courthouse for arraignment on ten indictments charging him with larceny. Even though he did not invent what came to be known as a "Ponzi scheme," a scam in which early investors are paid with money from new investors, Ponzi played the game on such a grand scale that the pyramid scheme bears his name even today. Ponzi had been serving a five-year sentence imposed by the United States District Court at the Plymouth County Jail. The new charges were brought by the State of Massachusetts, which convicted him in 1925.

On Saturday, May 19, 1928, Blake's body was the sixth to be located. The return of Blake's body to Brockton was delayed until Monday night because there was no train service from Greenville on Sunday. Once the body arrived in Brockton, it was brought to the Sampson Funeral Home, where it was prepared before being brought Tuesday morning to the Blake home at Obery Heights in Plymouth. The funeral was scheduled for 1:30 p.m. Tuesday at First Church in Plymouth.[142]

At noon, the body was taken from the home to the church, where friends and family could view the body. Hundreds attended the simple service, which was conducted by Reverend Alfred Hussey of First Church. The service was brief, with no music or eulogy. Both the district and probate courts were closed at noon out of tribute to the sheriff. Police and public officials from throughout the country were in attendance, as were officers from Plymouth County with whom Blake worked. The Massachusetts State Guard Veterans Association, in which Blake had been a captain and major, was represented by Colonel Henry L. Kinkaide of Quincy. The George Dunbar Unit of Brockton, with which Blake was active, also sent a delegation. The Brockton and District Bar Association was also well represented. After the church service, the body was brought back to Brockton for burial at Union Cemetery. The funeral cortege from Plymouth to Brockton included an escort by the state police and was led by several flower cars. As proof of Blake's popularity among prisoners

Plymouth County sheriff Earl P. Blake (*right*) escorts Charles Ponzi from Plymouth County Jail to the Suffolk County Courthouse for arraignment on ten indictments of larceny, June 23, 1924. *Bettmann Collection, Getty Images.*

at the House of Corrections, all inmates subscribed for a floral piece.[143] The committal service was performed by Rector David Matthews of Brockton's St. Paul's Episcopal Church, of which Blake was a member.[144] Blake's widow would remain in Plymouth until her death at the age of sixty-four on May 9, 1939.

Dr. Arthur F. Peterson

Born in Brockton, Massachusetts, on December 24, 1885, Arthur F. Peterson was the son of Swedish immigrants Patrick and Tina (Johnson) Peterson. After completing grammar school at the age of eleven, he went to work as an edge setter at George E. Keith Shoe Company, one of the largest shoe factories in Brockton. After five years of work, he entered evening high school and graduated in 1911 after six years. In 1912, Peterson entered Baltimore College of Physicians and Surgeons, which merged with the Medical College of the University of Maryland in 1915. It was from here Peterson would receive a Doctor of Medicine degree in June 1916. While a student, he served as president of the Craftsman's Club and Phi Chi fraternity (one of the largest medical fraternities in the country). He also served as president of his class and was elected chairman of the senior executive board of his class.[145] Following graduation, he completed an internship at Mercy Hospital in Baltimore, Maryland, for one year, which ended just as the United States entered World War I. Determined to serve, Peterson joined the Medical Corps of the United States Army in June 1917 and was commissioned a first lieutenant. He was stationed for three months in Syracuse, New York, in charge of the tuberculous examination board before being transferred to Camp Wadsworth in Spartanburg, South Carolina, in charge of tuberculosis examinations. Before he could be sent overseas, the war ended in 1919, and Peterson received an honorable discharge with a rank of captain; he remained a member of the U.S. Army Medical Corps, rising to the rank of major in 1924.[146]

In 1920, he married Sarah Peer of Dover, New Jersey, whom he had met while serving at Camp Wadsworth. Sarah had served as a nurse for the American Red Cross during the war, including six months overseas. The couple had two sons: Robert A., born on January 3, 1922, and Allen D., born on May 31, 1925. Upon returning to Brockton with his bride in 1920, Peterson was appointed as the school physician. In 1924, he was appointed

as city physician. He also served as the medical examiner for the U.S. Veterans Bureau.

Peterson's body was found on Saturday, May 19, using grappling hooks. The body was returned to Brockton along with that of Sheriff Blake on Monday, May 21, and taken into the care of C.F. Dahlborg and Sons. The funeral was held on Tuesday, May 22, at 2:00 p.m. from the Peterson home at 69 Linnea Avenue in Brockton. A viewing was open to the public beginning at 10:00 a.m. until the service, which was conducted by Reverend John A. Swanson, pastor of the Swedish Baptist Church in Brockton. As a military veteran, Dr. Peterson was entitled to a full military service, but at the request of Mrs. Peterson, the military band did not play, nor was a caisson used to transport the body to Union Cemetery, where Peterson was buried. However, seventy-five members of the Brockton Post of the American Legion and the Veterans of Foreign Wars were present, and the committal service at Union Cemetery was read by Rabbi David Goldberg, former chaplain of the Legion Post. As Peterson's body was lowered into the grave, taps was played and a three-round volley was shot.

The simple eulogy provided by Reverend Swanson aptly summed up the type of person Dr. Peterson was:

Dr. Arthur S. Peterson, no date.
Courtesy the Brockton Historical Society.

> *His greatness does not lie in his achievement as a physician and man of science…the fact that he employed his knowledge and trade for the welfare of his fellow man. He did not look for fame or wealth. His aim was to help those who were afflicted. He gave himself to his country when it called for sacrifice in the Great War. His unselfish and willing spirit led him to whole hearted labor when there was need. To alleviate distress, to lighten the burden, to spread cheer was his life. He loved his calling and he loved his humanity.*[147]

Dr. Peterson also loved his family, leaving his two sons, ages six and three, to grow up without him. On Tuesday, May 22, 1928, the Brockton School

Board made resolutions and voted in favor of continuing his salary until the end of the school year, but it was not enough to support the family; the 1930 and 1940 census records listed Sarah Peterson working as a nurse.[148]

JOHN SANDBERG

John Sandberg was one of the influential members of Brockton's Swedish community at the time of his death. A Swedish immigrant, Sandberg was born on October 12, 1879, in Kristianstad, Sweden. He arrived in New York on April 24, 1902, aboard the sailing ship *Oscar II*. After moving to Brockton, he worked as a machinist, petitioning for citizenship on February 23, 1905. He became a naturalized citizen on March 2, 1910, at the age of thirty.[149] He was married to Alma M. Johnson, who was born on February 7, 1881, also in Kristianstad.

A successful machinist, Sandberg opened the Brockton Tool Company in 1912. As his business grew, so did his wealth. In 1925, the couple built a 1,926-square-foot home at 345 Copeland Street that still stands today. An avid outdoorsman, he often took both hunting and fishing trips and traveled to Moosehead Lake for many years.

On January 19, 1927, the couple hosted Carl Wilhelm Ludwig, hereditary Prince of Sweden and Duke of Södermanland and second son of King Gustav V of Sweden, at their home before his lecture at the Strand Theatre. When the prince arrived at the Avon/Brockton line from Boston, he was met by a group of Swedish members of the Brockton Police Department who escorted him into the city to city hall for a brief reception. There he was greeted by Mayor Bent and other members of the reception committee, including John Sandberg, former state senator Edward N. Dahlborg (brother of Moosehead victim Fred Dahlborg), Walter Rapp, former mayor Roger Keith, C.W. Otto Lawson, Bernard Saxton, state representative John Holmes, Oscar Peterson and Superintendent of Schools John Scully.

Arriving in the city later than planned, the prince accompanied Mr. Sandberg to his home for a dinner, where he was greeted by Mrs. Sandberg. Because they arrived only one hour prior to the 8:00 p.m. lecture, the *Brockton Enterprise* reported that the prince "restrained from eating heartedly" before retiring for a brief rest. In addition to the Sandbergs, dinner guests included C.W. Johnson, Swedish Vice-Consul of Boston, and J. Jay Elliot,

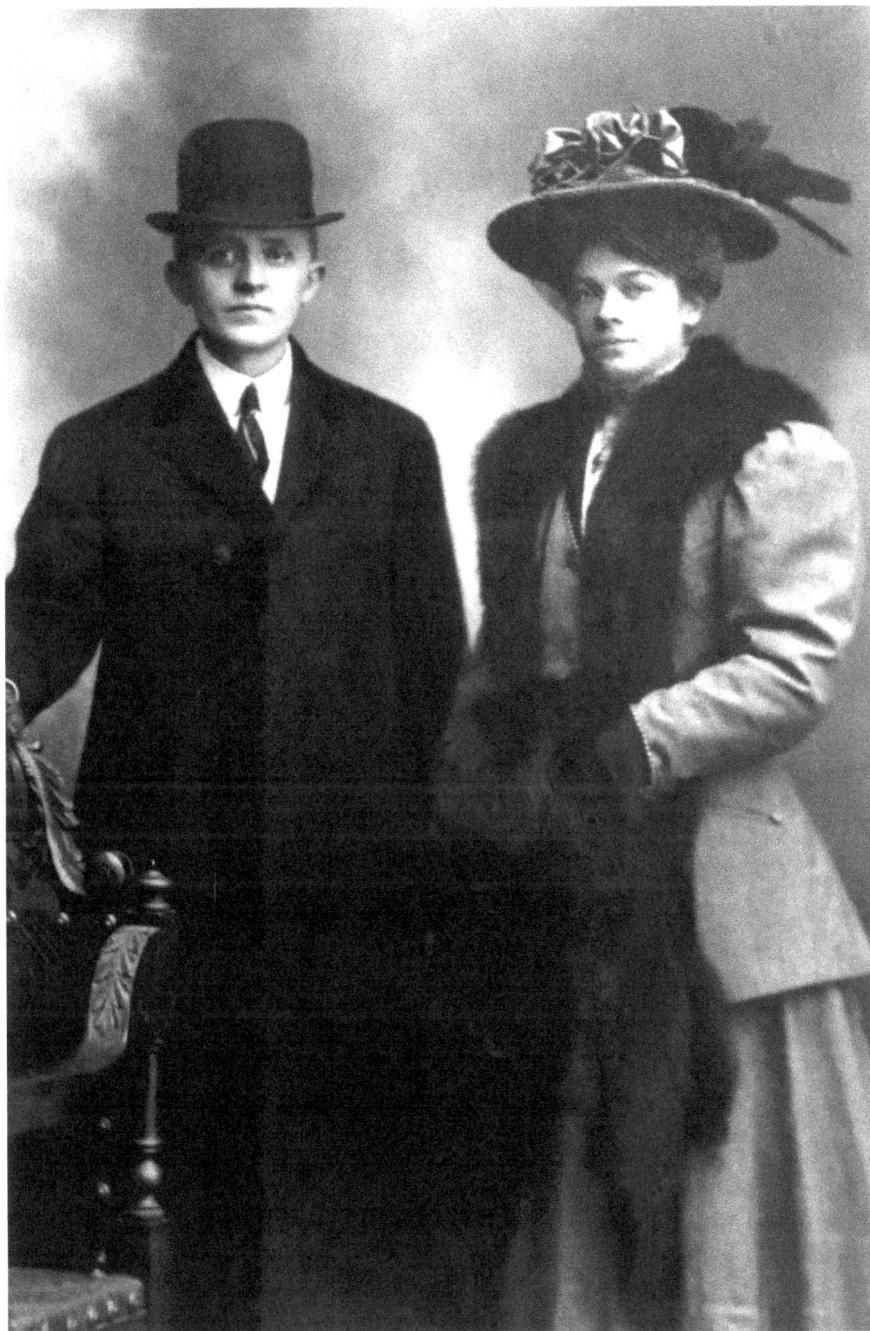

John and Alma Sandberg, circa 1910s. *Courtesy the Sandberg family.*

Left: John Sandberg, no date. *Courtesy the Sandberg family.*

Below: John Sandberg Jr. stands in front of the family's home 345 Copeland Street, Brockton, circa 1930. *Courtesy the Sandberg family.*

general manager of the tour. During the dinner, the prince gave the couple a modern-day photo of Sweden.

Entitled "Big Game in Pygmy Land," the lecture was the opening of his speaking tour on his many years in Africa and his hunting exploits before an audience of more than 1,200 men and women. Following the lecture was a reception at Vasa Hall, where he was entertained by an all-male glee club. One of the impressive features for the prince was the illuminated belfry of the First Lutheran Church, which possessed a flag presented by the prince's father, King Gustav V, in 1923. The prince spoke with Reverend Peter Froeberg, DD, pastor of the church, and expressed his disappointment that he was unable to visit the church during his stay due to the many activities in his honor. Originally, the prince was to spend the

Left: Alma Sandberg and son John Jr., no date. *Courtesy the Sandberg family.*

Below: In addition to fishing, John Sandberg was an avid hunter. He is pictured here with unidentified friends, no date. *Courtesy the Sandberg family.*

night at the Sandberg home, but instead he returned to Boston at 11:30 p.m. that night, as he was to give another lecture at Boston's Symphony Hall the next evening.[150]

Eighteen months later, on June 8, 1928, the body of John Sandberg was recovered from Moosehead Lake, twenty-seven days after he drowned when the *Mac II* sank. The funeral service was held on Sunday, June 10, from the Sandbergs' Copeland Street home and conducted by Reverend Thomas S. Roy, Pastor of the First Baptist Church in Brockton; it included the singing of "One Fleeting Hour," which John Sandberg had requested his wife have sung should he die before her. Hundreds attended the funeral, including a large group of employees of the Brockton Tool Company along with representatives of the Vega Club, Paul Revere Masonic Lodge and Kiwanis Club, of which Sandberg was a member. This was also the first funeral to be attended by the lone survivor of the tragedy, Captain Lays. Lays had not attended the previous seven funerals since he was still at Moosehead Lake assisting in the recovery of the bodies.[151]

Alma Sandberg would remain in the Copeland Street home until her death on August 12, 1960, at the age of seventy-nine. It was there she would raise the couple's son, John Sandberg Jr., born on April 6, 1928, one month before his father would leave on his annual fishing trip—and two months old when his father returned to be buried. His will, written in 1920, and filed in probate court on June 25, 1928, left his wife his entire estate, estimated at approximately $250,000.[152] John Sandberg Jr. moved to Smyrna, Georgia, in the 1960s, where he would practice pediatric medicine. He died on August 25, 2010, at the age of eighty-two.

W. SAMUEL BUDDEN

Walford Samuel Budden was born on June 17, 1892, in Greenville, Maine, to Henry and Carrie Emma Budden. His father was a bookkeeper who had emigrated from England in 1871. After Budden attended school, the 1910 federal census lists his occupation at the age of seventeen as a fireman on a steamboat. He married Della Le Mieux of Canada around 1911, and their first child, Drucilla Inista Etta Budden, was born on November 3, 1912. On her birth certificate, Budden listed his occupation as a clerk in a store. In 1917, his World War I draft registration card listed his occupation as a clerk for D.T. Sanders and Son Company, which was a hunting and fishing

Left: Sam Budden and his son, Girard Burrell, no date. *Courtesy the Moosehead Historical Society.*

Below: Sam Budden and his wife, Della, no date. *Courtesy the Moosehead Historical Society.*

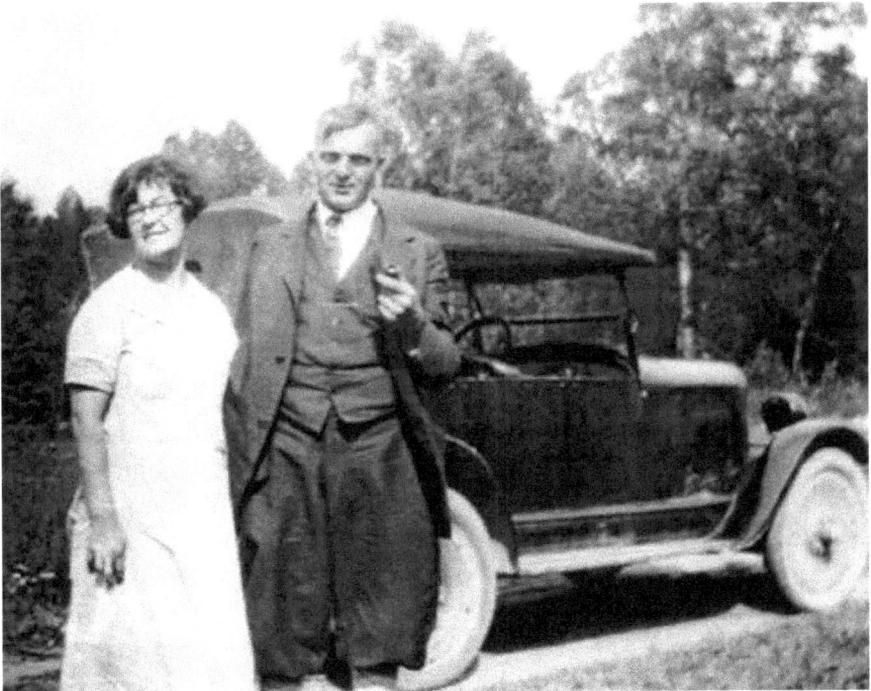

outfitter in Greenville. The birth certificate of his daughter Eleoda, born on January 28, 1918, lists his occupation as "clerk in woods," as does the birth certificate of his son Girard Burrell B. on April 29, 1920. The 1920 census recorded on January 5, 1920, lists his occupation as a scaler for a sawmill. Most likely his work was seasonal, and he often worked as a guide for fishing parties headed from Greenville to the various fishing camps on Moosehead Lake. After the accident, news accounts list him only as the guide or pilot. There was no local paper in Greenville, and accounts in Maine papers focused on the search for the bodies, with little info about the victims beyond their occupations. For the Brockton papers, focus was on the local victims and recovery efforts, and little attention was paid to the victim unknown to their readers.

Sam Budden's body rose to the surface on June 20, 1928, almost forty days after the sinking of his boat. The body was found 150 feet from shore in a direct line from where the boat was raised. It was located by Alexander MacDonald, a guide at the Sperry Camp on Moosehead Lake. Upon learning the news, Mayor Bent sent the following telegram to Budden's widow: "Glad to hear your long vigil is ended. With sincere personal regards." Budden is buried at Greenville Cemetery.[153]

FRANK W.E. MOBERG

Frank Moberg at his confirmation at First Evangelical Lutheran Church, Brockton, 1899. *Courtesy the First Evangelical Lutheran Church, Brockton.*

Frank Walter Emmanuel Moberg was born in Brockton on September 14, 1884. He was the fourth of five children born to Swedish immigrants Martin and Annie (Burgess) Moberg. After finishing local schools, he went to work as a shoe cutter in one of Brockton's prospering shoe companies until he decided to attend Tufts Dental College. After graduating on June 17, 1918, he opened a dental practice at 231 Main Street in the downtown area of the city.[154] By the time of his death, his offices had moved to the Vasa Building at 863 Main Street in the Campello (Swedish section of Brockton). His advertisement

EDWARD N. DAHLBORG
Svensk Advokat
106 Main St. Room 417
Evenings by appointment
116 Hillberg Ave. Tel. 4522 W.

EDWARD N. DAHLBORG
Svensk Advokat
106 Main St. Room 417
Evenings by appointment
116 Hillberg Ave. Tel. 4522 W.

· DR. F. W. MOBERG ·
Svensk Tandläkare
Kontorstimmar: 9—12 f. m., 2—6 e. m.
VASA BUILDING
863 Main St., Brockton, Mass.

C. F. DAHLBORG & SONS
Svenska Likbesörjare
Telephone Connection
Dahlborgs Block Campello

C. F. DAHLBORG & SONS
Svenska Likbesörjare
Telephone Connection
Dahlborgs Block Campello

Advertisements for Dr. Moberg in First Evangelical Lutheran Church newsletter before and after the tragedy, 1928. *Courtesy the First Evangelical Lutheran Church, Brockton.*

in the First Lutheran Church newsletter listed *Svensk Tandläkare*, which translates to "Swedish Dentistry."[155]

In addition to his professional career, Moberg was a member of many social organizations, including the Vega Club, Vasa Order of America (a Swedish American fraternal organization), the Scandinavian Fraternity of America and the Knights of Pythias. He was also an active member of the First Lutheran Church of Brockton, where as a lover of music and tenor he participated in the church's chorus. This love of music also led him to be one of the founders of the Myrtle Male Quartette, with which he was associated for many years but had left by the time of his death.[156]

On June 21, 1928, he was the last of the victims to be located. Unmarried, Moberg left behind his three older sisters—Jennie Moberg Steele, Florence Moberg Sterndahl and Ella Moberg—as well as his younger brother, George Arthur Moberg. Hundreds of relatives, city officials and members of the fraternal organizations of which Moberg was a member attended the funeral at Sampson Funeral Home, including Mayor Bent and his wife, Elva Ahlstrom, who was a cousin of the Mobergs. The funeral was conducted by Reverend Peter Froeberg, DD, pastor of the First Lutheran Church in Brockton. In his eulogy, Froeberg described Moberg as a successful

professional with a "sunny disposition and optimistic state of mind." He was also charitable to those around him and often used his business in service to others "without thought to personal gain or profit." After the funeral, interment was at Melrose Cemetery.[157]

CAPTAIN JAMES E. LAYS: THE ONLY SURVIVOR

Born on February 19, 1871, in Westville, Nova Scotia, James Edwin Lays came to Brockton at the age of seven. After completing both grammar school and high school in the city, he learned the carpentry trade and worked in that capacity until March 1893, when he was appointed as a substitute letter carrier at the local post office. He was promoted to regular service in 1894 and served in that position for eleven years. In 1903, Lays became a member of the reserve Brockton police force. On December 6, 1905, he was appointed to the regular police force by Mayor Edward H. Keith. His first "beat" was covering a route on Main Street.

Lays rose rapidly through the department's ranks. In 1906, he was named an acting inspector by City Marshal Ira Kingman, a post he held until being assigned as an inspector for the liquor squad, on which he served from 1908 to 1909 and then again in 1911.[158] The liquor squad consisted of inspectors who were assigned to enforce the city's no-license law banning the sale of alcohol.[159] The city of Brockton was no-license from 1899 to 1909, with the exception of one year.[160] Brockton remained dry until the end of Prohibition.

Lays was promoted to sergeant on March 12, 1912, and named acting city marshal by Mayor Harry C. Howard in September 1912 when City Marshal Micah Allan fell ill. Howard named Lays city marshal on January 12, 1914.[161] He was again named city marshal in 1915 and 1916 under Mayor John S. Burbank. In 1917, under Mayor Stewart B. McLeod, Lays was promoted to the rank of captain. He would again serve as city marshal in 1921 and 1922 under Mayor Roger Keith. After 1922 until his retirement in 1937, he would be in charge of the day and night desks of the Brockton Police Department except during City Marshal William J. Murphy's tenure, when he was made chief inspector of the criminal investigation unit beginning in 1931.

Holding the rank of captain for twenty years, Lays was affectionately known as "Cap" around the city of Brockton even after his retirement. Lays served a distinguished thirty-two-year career, as evidenced by his appointment as city marshal for five years under four separate mayors. The

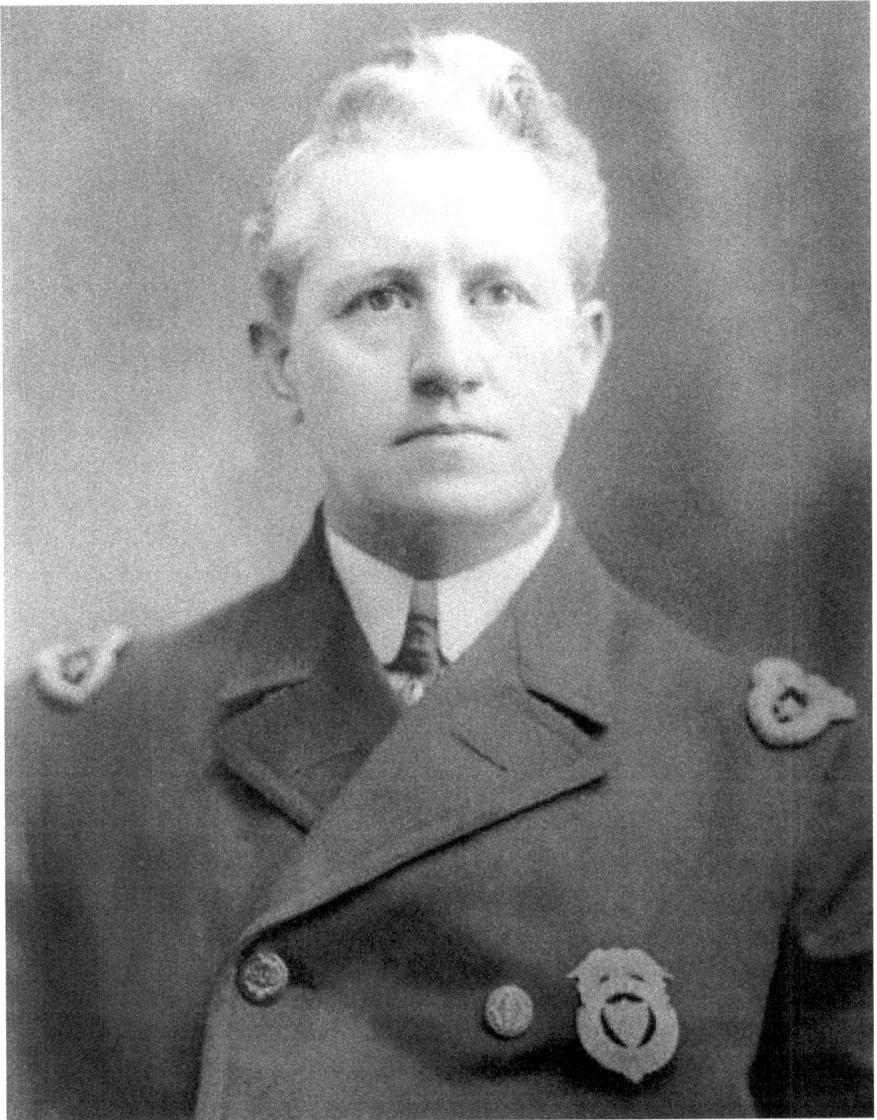

Police Captain James E. Lays, no date. *Courtesy the Lays family.*

city marshal was an appointment of the current mayor from within the police ranks, and at the time—mayoral terms were for a period of one year—the appointment was rarely long term. During his career, he was also awarded several commendations, including for assisting another patrolman with rescuing a family from a burning house and arresting a man for attempted

murder by smashing down the door of the closet the man had barricaded himself in and disarming him of his weapon. Lays was also on duty on April 15, 1920, the day of the famous Sacco and Vanzetti case. Lays took the call about the robbery at the Slater & Morrill Shoe Company in South Braintree, Massachusetts, and murder of the paymaster and his guard. Lays dispatched officers to block all roads leading into the city and question occupants of all cars.[162] Although the initial search was unsuccessful, Nicola Sacco and Bartolomeo Vanzetti were arrested on May 5, 1920, by Brockton policeman Michael J. Connelly, who boarded their streetcar as it was coming into Brockton from West Bridgewater after learning that the two had left the garage where they were believed to have been hiding. After a long legal battle, Sacco and Vanzetti were executed on August 23, 1927; however, doubts of their guilt remained for decades, and in 1977, Massachusetts governor Michael Dukakis issued a state proclamation absolving both men.

Even with his successes, Lays did not seek glory. He was known for his eye for detail and noted for his ability to return to the station with criminals after hearing police descriptions. Outside of work, Lays enjoyed hunting, fishing and gardening. He married Luella N. Campbell on December 8, 1894, in Brockton, and they had two sons: Alan F., born on December 13, 1899, and Lawrence E., born on May 28, 1896. Luella Lays died on August 31, 1903, of eclampsia during the birth of their daughter, Ruth Luella Lays, who did not survive. He married Georgina Hutcheson on December 5, 1905, just two weeks after being named a patrolman with the police department. His son Alan would become a line keeper for New England Telephone and Telegraph, while his oldest son, Lawrence, is listed in 1910 as a resident of the Cottage Hospital for Children in Worcester and then from 1917 until his death as a resident of Monson State Hospital in Monson, Massachusetts. Both institutions were known for treating patients with epilepsy.

In 1937, Lays retired from the police department. From December 1941 to November 1942, he served as a civilian defense official but resigned, citing that "new dim-out regulations called for an individual more active than he."[163] Lays passed away on March 15, 1947, at his home at 58 Windsor Avenue, Brockton, having been in failing health for some time. In addition to his wife and sons, he left behind four grandchildren and several nieces and nephews. His funeral was held at the Hall Funeral Home, with interment at Melrose Cemetery.[164]

CHAPTER 7

"SPARE NO EXPENSE"

S pare no expense" were the words of Mayor Bent to the officials in Maine when news of the tragedy reached Brockton on May 14, 1928. By the time the body of Dr. Frank Moberg was recovered on June 21, the City of Brockton had appropriated $3,100 to pay bills for search party expenses. On June 10, resolutions on the deaths of the nine Brocktonians were adopted by the board of aldermen. That same day, the board unanimously passed and appropriated $1,200 for search parties in connection to Moosehead recovery operations and a transfer of $1,900 from the reserve account for the same purpose. However, on July 26, an order for an additional $1,203.22 to be transferred from the reserve account to the Moosehead Lake account at the city council meeting brought considerable debate and dissent. Leading the way was City Councilman Carlton Howland, who argued that the original appropriation passed in June had been illegal and asked that the proper authorities be requested to seek a legal opinion on the appropriation and a joint special committee be assembled to make a public subscription to meet the expenses of the tragedy. He also stated that "legal action is to be brought against the city as a result of that transaction." Howland went on to argue:

We are soon to become the laughing stock of the city....As representatives of the people we do not take time to investigate before we vote on these questions. Thirty-one hundred dollars already has been spent as a result of the Moosehead Tragedy, and it has been spent illegally. How do we know

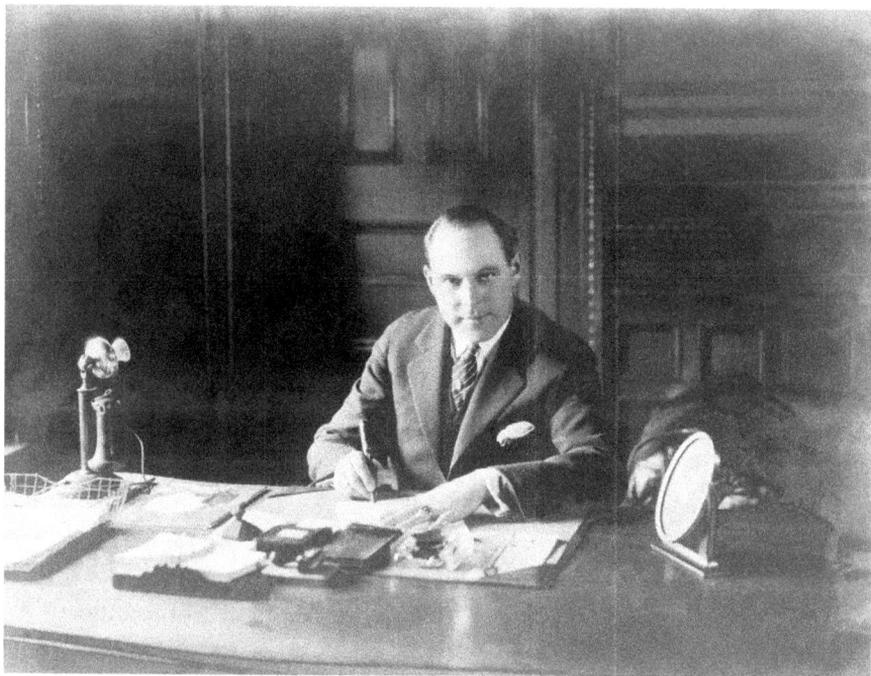

Mayor Harold D. Bent, 1925. *Courtesy John Murphy.*

there won't be several more bills come along to cover other expenses of the accident....I believe the people of Maine have taken a golden opportunity to make a clean-up. My opinion is derived at looking over the bills in the office of the city auditor.

Howland was supported in his dissent by fellow councilman Horace C. Baker, who stated, "It's the same old story. If they can steal $3100, they feel like they can steal some more. Just because some people promised to back up the mayor, even though he was wrong, is no reason why we should uphold him." These quotes came from the *Brockton Daily Enterprise*. Minutes of both the Brockton City Council and Brockton Board of Aldermen only detail specific motions and do not provide transcripts of speeches and debate of the council or board. However, the paper reported that the order passed with four dissents, including Baker and Howland and two abstentions. Additionally, orders that a joint special committee be appointed to make arrangements for conducting a public subscription to meet the expenses of the tragedy and orders asking that the proper authorities be requested to

secure legal opinions of the appropriations were tabled until the last meeting of the council in 1929. The next step was for the board of aldermen to approve the appropriation.[165]

The board of aldermen was expected to pass the order at its meeting scheduled for Monday, August 6, 1928. On Saturday, August 4, two days before the aldermen were to vote, Howland's July 26 remark at the council meeting about legal action came true when attorney James E. Handrahan filed a restraining order on behalf of Councilmen Carlton Howland and Horace C. Baker with the clerk of the Superior Court at Plymouth. In addition to the councilmen, the order contained the signatures of eighteen Brockton citizens, including Michael H. Walsh, Frank V. German, John A. Peterson, Ludwig Backlund, Arnold Backlund, John F. Farrell, John S. Nelson, John W. Canavan, John F. Gorman, Clarence R. Johnson, Katherine H. Johnson and C. Hokanson. Named in the order were Mayor Harold Bent; city auditor Chester Swanson; city treasurer Calvin R. Barrett; and the aldermen H. Merton Snow, John W. O'Neil, Benjamin A. Hastings, Arthur J. Bettridge, Samuel Shapira, Joseph Kavanaugh and Charles J. Helander. According to the petitioners, it "was beyond the corporate power of the city and its officers to expend money raised by taxation as compensation to persons for their services in searching for the lake victims and for expenses alleged to have been incurred in connection to the search."[166]

On Monday, August 6, 1928, Judge Stanley E. Qua, in an equity motion session of Superior Court in Boston, issued a temporary injunction against Mayor Bent, the board of aldermen, city auditor Swanson and city treasurer Barrett, restraining them from spending any additional money for Moosehead Lake expenses. He also scheduled an additional hearing for the following Monday, August 13. As a result of the injunction, that night at their meeting the aldermen voted to table the matter of the Moosehead Lake expenses for two weeks on the motion of Alderman Bettridge. The *Brockton Enterprise* reported that during the motion, Alderman Bettridge argued that the city had expended larger sums of money for other accidents, including the Grover Factory Fire in 1905 and an accident at the Avon Railroad Station, and there had been no question about legality of payments in those cases. It further reported that Bettridge argued that the "honor of the city was at stake and that the refusal of Brockton City Government to meet honorable obligations was a blot upon its fair name."[167]

In rebuttal, Councilmen Howland and Baker published a 622-word letter in the August 8, 1928 edition of the *Enterprise*. In their response, they referred

to Bettridge's criticism as a "flow of oratory" seen often from the alderman when he disagreed on a matter and argued:

> *If he* [Bettridge] *had taken the trouble to consult the revised ordinances of 1926, page 63, special acts of the Legislature, he would see that the members of the city government at that time did things in a sane and legal manner and were granted authority by the Legislature for what they did in the Grover disaster. In the Avon Wreck, so little money was spent that we doubt whether there was any mention of it in city records.*[168]

They also stated that while it was reported that the State of Maine had spent a reported $7,000 on recovery efforts, they doubted that those expenditures included the types of items on Brockton's bills. Specifically, they criticized the mayor for payment on $599 of expenses for which no receipts were made public.

The same issue also included the headline, "Widows and Friends Move to Raise Search Sum." The brief article noted that widows, close relatives and friends of the victims were distressed by the controversy and were making plans to subscribe the necessary money to pay the outstanding bills. The next day, August 9, the paper ran the headline, "Search Bills on File Are Itemized" and gave a breakdown. The $599 spent by the mayor from city funds was reported as thirty-nine days of expenses from May 14 to June 22 for labor, board, transportation to and from Maine, boats and grappling irons. The following is a breakdown of expenses of the total $4,207.23 bill received from Maine:

- *F.A. MacKenzie, Proprietor of West Outlet—$2562.63*
- *Dr. Pritham—Medical Examiner—$10.00*
- *Diver Brooks—$900.00*
- *Telephone Calls—$135.60*
- *Inspectors—$599.00*
- *$147 anticipated, but not yet received*
- *$50.41 unspecified rebate.*[169]

Calculations of these figures results in a balance of $1,203.82 after subtracting the $3,100.00 previously allocated and paid. The allocation in question was $1,203.22, leaving an additional $0.60 unaccounted for. It is possible that the figures reported were incorrect, but sadly no other documentation was found to exist.

The same article reported that family and friends were now determined to carry out a personal subscription to pay the outstanding bills and planned to have the money on hand before the next council meeting. Alderman Bettridge offered the following response to the August 8 letter of Howland and Baker: "Out of courtesy to the many grief stricken widows, I do not care to enter into a newspaper controversy with the councilmen from Ward 4 as I realize it will not help matters. The councilmen saw fit to deviate from the question and delve into personalities thereby excusing me from further comment."[170]

The next mention of the controversy was on August 21, when the *Enterprise* reported on the August 20 meeting of the board of aldermen that family and friends of the victims had subscribed the necessary funds to pay the outstanding bill, wanting to end the continued controversy. However, when the matter of payment came up for consideration at the meeting, Alderman O'Neil quickly motioned to table it, quickly seconded by Alderman Kavanaugh. This move prevented Alderman Bettridge, who had spoken at previous meetings fervently in favor of the appropriation, to present receipted bills showing that the "money owed had been paid by the widows, relatives and intimate friends of the nine deceased men."[171] In reality, the matter would not fully be closed until May 14, 1929. Although no court proceedings exist, the original handwritten court docket was found at Plymouth Superior Court and lists the dates of filings and orders. On December 19, 1928, Judge Qua made the August 6 injunction permanent, with a final decree of perpetual restraint that permanently prevented the city from ever making the payment of $1,203.22 and ordered the sum of $48.20 to the complainants, a sum paid on January 10, 1929. The final entry to the docket was made on May 14, 1929, noting, "Execution returned satisfied in full"—a year and a day from the tragedy.[172]

EPILOGUE

W hen tragedy strikes, time does not stop. There are moments of grief, reflection and tribute, but the world moves on. Even as Brockton mourned the loss of its nine sons, life continued. It also changed for many, not just the families who now had an empty chair at the dinner table. At the Brockton Fire Department, Chief Daley's death meant that whoever was promoted to chief would leave a vacancy in his rank for another to be promoted, leaving yet another vacancy and so on. And although Assistant Chief Frank Dickinson had been appointed acting chief in June, under civil service requirements he and others who wanted to be considered for the appointment as permanent chief and other promotions would need to sit for the civil service exam.

Dickinson was challenged for the chief position by Second Deputy Chief Murphy and Captains Murphy, Taylor and Jenkins. For the office of first deputy, Second Deputy Murphy (who was next in line) was challenged by Captains Gullefer, Jenkins, Taylor and Murphy. Seven lieutenants—Bell, Vinton, Carroll, McCarthy, Bussey, Seavey, Daniel and Long—took the exam for the promotion to captain. Lieutenant examinations were scheduled for August. Examinations took place during the morning of July 18, 1928.[173] During the exam, Captain Stack was put in charge of the department for all single-bell alarms. If there had been multiple-alarm fires, the exams would have ceased and been destroyed so that participants could respond to the fire. However, according to the *Enterprise*, only one fire was reported, at the 30 Farrington Street home of Mr. and Mrs. John Baynes. Captain Stack led

men from the Central and Montello Fire Stations to fight what the paper called a "stubborn fire" believed to have been started in the basement by the Baynes's four-year-old son, John Baynes Jr., playing with matches. The *Enterprise* reported that "Captain Stack demonstrated marked ability as a leader and although the fire gained considerable headway…two water lines plus several chemical streams soon leveled it."[174]

When the examination list was compiled and released by the Civil Service Commission, Dickinson ranked first. At the August 6 meeting of the board of aldermen, Mayor Bent put forth Dickinson's name for approval and Deputy Chief Murphy to be raised from second to first deputy, with no opposition. However, the board of aldermen went into executive session over the selection of second deputy and captain. After debate, Captain Gullefer, who was first on the list, was passed over in favor of Captain Frank Taylor, who was second on the list. Lieutenant Charles McCarthy was promoted to captain after some initial objections, even though he was first on the examination list.[175] These promotions occurred at the same aldermen's meeting where the search bills were tabled as a result of the injunction handed down two days before. The promotions also took precedence over the search bill story, appearing on page one when the latter was on page eleven.

Other vacancies left by the tragedy also needed to be filled. On June 4, 1928, the board of aldermen approved the mayor's appointment of state representative John Holmes to fill the vacant seat of G. Fred Dahlborg as highway commissioner.[176] On June 22, 1928, Charles H. Robbins was appointed as Plymouth County sheriff by Governor Alvin T. Fuller to fill the post left vacant by the death of Earl P. Blake. A veteran of World War I, Robbins was first appointed as a deputy sheriff by Sheriff Henry S. Porter in 1917 and reappointed by Sheriff Blake. Robbins would remain Plymouth County sheriff until 1955.[177]

On July 14, 1928, Dr. John J. McNamara was confirmed as examining physician for the veterans bureau, replacing Dr. Arthur Peterson. Shortly after Dr. Peterson's death, several non-veteran physicians applied for the post, but leading war veterans favored a veteran's appointment. Born in New York in 1874, Dr. McNamara had been a physician in Brockton since the early 1900s. In 1912, he was appointed associate medical examiner by Governor Foss. During World War I, he rose to the rank of captain in the U.S. Army.[178] Dr. Alfred Lemay replaced Peterson as school physician.[179]

The businesses of George Howard and Sons and C.F. Dahlborg and Sons would continue. Today, the funeral part of Dahlborg continues as Dahlborg-MacNevin Funeral Homes, with locations in both Brockton and

Storefront of Shepard Market, circa 1940s, once owned by Knute Salander. *Bauman Collection, Stonehill College.*

Lakeville, Massachusetts. Shepard Market remained open until the 1960s, and Sandberg's Brockton Tool Company would continue under Sandberg's partner, Levi Holmes, but move to neighboring Easton around 1940, continuing operation until it closed its doors in 1980.

Seventeen months after the tragedy, the crash of the stock market on October 29, 1929, sent the United States into the Great Depression. Although it took time to realize the enormity of the situation, for a city like Brockton, whose shoe factories numbered 244—the largest industry in the city—the impact was great. Almost immediately, shoe production dropped, and more and more workers lost jobs and businesses failed. Between 1929 and 1932, shoe production declined 32 percent, and W.L. Douglas Company sales dropped from $9.5 million to $4.4 million. The city was in

crisis, and it would take years to recover. The beginning of the New Deal in 1933 on a national level would eventually help ease some of the poverty and unemployment that would plague the city, and shoe production began to pick up as war in Europe threatened.

The Hurricane of 1938 brought eighty-mile-per-hour winds and great destruction to the city,[180] but the Strand Theatre Fire and the loss of thirteen firefighters in March 1941 would send the city back into mourning. Those promoted in the fire department after Chief Daley's death, including Chief Dickinson and Deputy Chief Murphy, would face the biggest challenge of their careers. World War II would then overshadow the loss at the Strand, and Brockton would continue to weather storms, natural, political and economic. Although it may seem that the story of the loss of nine Brocktonians and their Maine guide on a fishing trip to Moosehead Lake has faded into history, it certainly is not forgotten.

NOTES

Chapter 1

1. Benson, *Images of America: Brockton*, 9.
2. *Brockton Daily Enterprise*, March 13, 1928, 1.
3. Ibid., March 28, 1928, 1.
4. Ibid., April 4, 1928, 1.
5. *Brockton Times*, May 8, 1928, 1.
6. *Brockton Daily Enterprise*, March 9, 1928, 1.
7. Ibid., April 13, 1928, 1.
8. Ibid., March 19, 1928, 1.
9. Varney, *Gazetteer of the State of Maine*, 260–61.
10. Ibid.
11. Calvert, *Kennebec Wilderness Awakens*, 47.
12. *Ninety-First Annual Report of the Municipal Officers of the Town of Greenville*.
13. Merrill, *Lakes of Maine*, 36–37.
14. Calvert, *Dawn Over the Kennebec*, 381.
15. Ibid.
16. Lowell, *Moosehead Journal*, 25.
17. Captain Charles A.J. Farrar, "Wilderness Writer and Adventure Provider," in Krohn, *The Courier*, 1, 8.
18. Harris, "New Mount Kineo House."
19. Hubbard, *Hubbard's Guide to Moosehead Lake and Northern Maine*, 210.
20. Merrill, *Lakes of Maine*, 51.

21. Harris, "New Mount Kineo House."
22. Brockton Fire Department, Moosehead Scrapbook, 4.

Chapter 2

23. Ibid., 6.
24. Ibid., 1.
25. Ibid.
26. Ibid.
27. Ibid., 7.
28. *Portland Press Herald*, "Moosehead Tragedy," 2.
29. Ibid.
30. Brockton Fire Department, Moosehead Scrapbook, 7.
31. Ibid.
32. Ibid.
33. Ibid.
34. Ibid., 3.
35. Ibid., 1.
36. Ibid., 2.
37. Ibid., 1.
38. Ibid., 12.
39. Ibid., 5.
40. Ibid., 9.
41. Ibid.
42. Ibid.
43. Ibid.
44. Ibid.
45. Ibid.
46. *Brockton Daily Enterprise*, "Mrs. Blake Hears News and Faints."
47. *Brockton Times*, "No Bodies Are Recovered May Employ Navy Divers."
48. Brockton Fire Department, Moosehead Scrapbook, 15.
49. Ibid.
50. Ibid.
51. Ibid., 7.
52. Ibid., 20.
53. King, "Spectacle of Horror."
54. Wikipedia, "List of Disasters in the United States by Death Toll."
55. Brockton Fire Department, Moosehead Scrapbook, 14.

56. Ibid., 16.
57. *Maine Fish and Game Magazine*, 2.
58. Brockton Fire Department, Moosehead Scrapbook, 20.

Chapter 3

59. Ibid.,18.
60. Ibid., 22.
61. *Portland Press Herald*, "Diver's Wife Drives," 1.
62. Brockton Fire Department, Moosehead Scrapbook, 21.
63. Ibid.
64. Ibid.
65. Ibid.
66. Ibid.
67. Ibid., 24.
68. Ibid., 21.
69. Ibid., 29.
70. Ibid., 28.
71. Ibid., 31.
72. Ibid., 44.
73. Ibid., 41.
74. Ibid., 45.
75. Ibid., 47.
76. Ibid.
77. Ibid.
78. Ibid., 49.
79. Ibid.
80. Ibid., 50.
81. Ibid.

Chapter 4

82. Ibid., 5.
83. Ibid., 10.
84. Ibid.
85. Ibid.
86. Ibid., 11.

87. Ibid.
88. Ibid., 13.
89. Ibid., 14.
90. Ibid., 25.
91. Ibid., 30.
92. Ibid., 35.
93. Ibid., 36.
94. Ibid.
95. Ibid., 35.
96. Ibid., 36.
97. Ibid.
98. Ibid.
99. Ibid.
100. Ibid., 47.
101. Ibid., 51.
102. Commercial Club Brocton, Meeting Minutes.

Chapter 5

103. Brockton Fire Department, Moosehead Scrapbook, 1.
104. Ibid.
105. Ibid., 29.
106. *Biddeford Daily Journal*, May 23, 1928.
107. Brockton Fire Department, Moosehead Scrapbook, 46.
108. Ibid.
109. Ibid.
110. Ibid., 29.
111. Ibid., 46.
112. Ibid., 41.
113. *Portland Press Herald*, "Moosehead Tragedy," 2.

Chapter 6

114. Ancestry.com, "Directory of Deceased American Physicians."
115. *Brockton Daily Enterprise*, "Loving Mother Feared Son's First Vacation."
116. Ibid., "Sight He Restored, Pays Him Tribute."
117. Ibid., "Military Rites Are Impressive."

118. Ibid.

119. *Daily Boston Globe*, "Will of Dr. Bridgwood, Tragedy Victim, Filed."

120. Ancestry.com, "Massachusetts, State and Federal Naturalization Records."

121. *Brockton Daily Enterprise*, "Bodies Will Lie in State."

122. Ibid., "Knute Salander Funeral Service."

123. Thompson, *History of Plymouth, Norfolk and Barnstable Counties*, 158.

124. Brockton Fire Department, "Celebrating 100 Years, Squad A," 2.

125. Thompson, *History of Plymouth, Norfolk and Barnstable Counties*, 158.

126. *Brockton Daily Enterprise*, "Nine of the 10 Men Who Were Drowned."

127. Brockton Fire Department, Concert and Ball Book, 30, 34, 36.

128. Ibid., 34.

129. *Brockton Daily Enterprise*, "Nine of the 10 Men Who Were Drowned."

130. Brockton Fire Department, Moosehead Scrapbook. 28.

131. *Brockton Daily Enterprise*, "Last Rites for Fire Chief Daley."

132. Ibid.

133. Thompson, *History of Plymouth, Norfolk and Barnstable Counties*, 298.

134. Ancestry.com., "U.S., World War I Draft Registration Cards."

135. Thompson, *History of Plymouth, Norfolk and Barnstable Counties*, 298.

136. *Brockton Daily Enterprise*, "Simple Rites for Dahlborg."

137. Ibid., "Nine of the 10 Men Who Were Drowned."

138. *Daily Boston Globe*, "Brockton on Its Good Behavior."

139. Ancestry.com, "U.S., Sons of the American Revolution Membership Applications."

140. *Brockton Daily Enterprise*, "Funeral Rites for H.C. Howard."

141. Thompson, *History of Plymouth, Norfolk and Barnstable Counties*, 96.

142. *Brockton Daily Enterprise*, "Dr. Peterson, Blake Bodies, Here To-Night."

143. *Daily Boston Globe*, "Bodies of Sheriff and Doctor Back."

144. *Brockton Daily Enterprise*, "Simple Services for Sheriff Blake."

145. Ibid., "Nine of the 10 Men Who Were Drowned."

146. Thompson, *History of Plymouth, Norfolk and Barnstable Counties*, 128.

147. *Brockton Daily Enterprise*, "Dr. Peterson Is Placed at Rest."

148. Ancestry.com, "1940 United States Federal Census."

149. Ibid., "Massachusetts, State and Federal Naturalization Records."

150. *Brockton Daily Enterprise*, "Sandberg Opens Residence to Prince William, Party."

151. Ibid., "Hundreds Pay Tribute at Rites."

152. Ibid., "Sandberg Wills $250,000 Estate All to His Widow."

153. Ibid., "Finding of Dr. Moberg's, Budden's Bodies."

154. *Brockton and Bridgewaters Directory, 1919.*
155. Herderösten, First Evangelical Lutheran Church.
156. *Brockton Daily Enterprise,* "Hundreds Pay Tribute at Bier."
157. Ibid.
158. *Daily Boston Globe,* "Brockton Police Changes."
159. Ibid., "Voting Today in 14 Cities."
160. Ibid., "No License Practical."
161. Ibid., "Lays City Marshall."
162. *Brockton Daily Enterprise,* "James E. Lays."
163. *Boston Herald,* "3 Brockton Civilian Defense Officials Quit."
164. *Brockton Daily Enterprise,* "James E. Lays."

Chapter 7

165. *Brockton Daily Enterprise,* "Baker Holds Maine People Robbed City."
166. Ibid., "Move to Halt Paying of Main Tragedy Bill."
167. Ibid., "Table Lake Search Bills."
168. Ibid., "Councilmen Give Answer to Bettridge."
169. Ibid., "Search Bills on File Are Itemized."
170. Ibid.
171. *Brockton Daily Enterprise,* "City Must Not Pay Lake Search Bills."
172. Plymouth County Superior Court/Brockton Civil Docket no. 19127.

Chapter 8

173. *Brockton Daily Enterprise,* "Firemen Compete for All Offices."
174. Ibid., "Captain Stack as Acting Chief."
175. Ibid., "Dickinson Fire Chief, Taylor Second Deputy."
176. City of Brockton. Board of Alderman Records, June 4, 1928, 142.
177. *Brockton Daily Enterprise,* "Chas. H. Robbins Appointed Sheriff."
178. Ibid., "War Veteran Appointed to Medical Post."
179. *Municipal Register of the City of Brockton for the Year 1929.*
180. Carroll, *Brockton,* 82.

BIBLIOGRAPHY

Ancestry.com. "Directory of Deceased American Physicians, 1804–1929." Provo, UT: MyFamily.com Inc., 2004. Database online.

———. "Massachusetts, State and Federal Naturalization Records, 1798–1950." Provo, UT: Ancestry.com Operations Inc., 2011. Database online.

———. "1940 United States Federal Census." Provo, UT: Ancestry.com Operations Inc., 2012. Database online.

———. "U.S., Sons of the American Revolution Membership Applications, 1889–1970." Provo, UT: Ancestry.com Operations Inc., 2011. Database online.

———. "U.S., World War I Draft Registration Cards, 1917–1918." Provo, UT: Ancestry.com Operations Inc., 2005. Database online.

Benson, James E. *Images of America: Brockton*. Charleston, SC: Arcadia Publishing, 2010.

Biddeford Daily Journal. May 23, 1928, 1.

Boston Herald. "3 Brockton Civilian Defense Officials Quit, 2 Accuse Mayor." November 29, 1942, 28.

Brockton and Bridgewaters Directory, 1919. Boston: W.A. Greenough & Company.

Brockton Daily Enterprise. "Baker Holds Maine People Robbed City with Rescue Bills." July 27, 1928, 6.

———. "Blake Death Shocks Town." May 15, 1928, second section, 1.

———. "Boat Pump Faulty, Inquiry Discloses." May 29, 1928, 1, 3.

———. "Bodies Will Lie in State; Daley, Bridgwood Here." May 18, 1928, 1.

———. "Bridgwood Funeral Sunday's 3. P.M." Extra, May 17, 1928, 2.

———. "Brockton Police for Strike Duty in New Bedford." July 27, 1928, 1.

———. "Captain Stack as Acting Chief Displays Ability at Blaze." July 19, 1928, second section, 13.

———. "Capt. Lays Last Saw Men Clinging to Sinking Boat." May 14, 1928, 1.

———. "Capt. Lays May Be Only One of 11 to Be Saved." May 14, 1928, 1, 14.

———. "Charles H. Robbins Listed for Sheriff." May 23, 1928, 1.

———. "Chas. H. Robbins Appointed Sheriff Plymouth County." June 22, 1928, 1.

———. "City Mourns as Sons Are Placed at Rest; Moosehead Lake Still Retains Three Bodies." May 21, 1928, 1.

———. "City Must Not Pay Lake Search Bills." December 19, 1928, second section, 13.

———. "Coolidge Wires Mrs. Earl Blake." May 16, 1928, 1.

———. "Councilmen Give Answer to Bettridge." August 8, 1928, 6.

———. "County Medical Society Mourns Tragedy Victims." May 18, 1928, second section, 15.

———. "Dickinson Fire Chief, Taylor Second Deputy." August 7, 1928, 1.

———. "Dickinson Slated to Be Fire Chief to Fill Vacancy." June 5, 1928, 1.

———. "Diver Finds No Bodies in Boat." May 18, 1928, 1.

———. "Dr. Goldberg Honors Dead." May 19, 1928, 9.

———. "Dr. Peterson, Blake Bodies, Here To-Night." May 21, 1928, 1, 11.

———. "Dr. Peterson Is Placed at Rest with Military Rites." May 22, 1928, 1, 8.

———. "Enterprise Reporters Fly to Tragedy Scene." May 15, 1928, 3.

———. "Examine Boat; Nothing to Show Cause of Sinking." May 19, 1928, 1.

———. "Fail to Fix Cause for Lake Tragedy." May 28, 1928, 1.

———. "Families of Moosehead Victims Receive Copies of Resolutions." August 14, 1928, 5.

———. "Finding of Dr. Moberg's, Budden's Bodies Brings Long Search to End." June 21, 1928, 1.

———. "Firemen Compete for All Offices." July 18, 1928, 1.

———. "Five Funerals Are Held; Skies Weep on Sad Gathering." May 21, 1928, 1.

———. "Funeral Rites for H.C. Howard." May 21, 1928, second section, 11.

———. "Heavy Boat, Weighed Down by Occupants, Ripped Seam." May 15, 1928, second section, 1.

———. "Hundreds Pay Tribute at Bier of Last Lake Victims." June 1928, 1.

———. "Hundreds Pay Tribute at Rites for John Sandberg." June 11, 1928, second section, 13.

———. "Inquiry Ordered into Lake Tragedy." May 18, 1928, 1.

———. "James E. Lays." March 17, 1947.

———. "Knute Salander Funeral Service." May 21, 1928, second section, 11.

———. "Lake Search Receipts Are Not Presented." August 21, 1928, 1.

———. "Last Rites for Fire Chief Daley." May 21, 1928, second section, 11.

———. "Lays Refuses to Leave 'His Boys.'" May 16, 1928, 2.

———. "Lays Risks Life to Lighten Boat." May 15, 1928, 1.

———. "Loving Mother Feared Son's First Vacation." May 19, 1928, second section, 13.

———. "Maine Opens Official Lake Tragedy Inquiry." May 22, 1928, 1.

———. "Mayor, Dr. French Off by Train to Moosehead Lake." June 7, 1928, 1.

———. "Mayor Inspirers Lake Searchers." June 12, 1928, 6.

———. "Mayor to Appoint Frank F. Dickinson Fire Dept. Chief." August 3, 1928, 1.

———. "Meeting Postponed or Shortened or Postponed by Tragedy." May 15, 1928, second section, 1.

———. "Military Rites Are Impressive." May 21, 1928, second section, 11.

———. "Mournful Caravan Brings Back Cars." May 17, 1928, Extra, 1.

———. "Movers, Sandberg, Budden Are Being Sought by Scores." May 21, 1928, 1.

———. "Move to Halt Raying of Main Tragedy Bill." August 4, 1928 page 1.

———. "Mrs. Blake Hears News and Faints." May 15, 1928, Extra, 3.

———. "9 Local, One Plymouth Man Feared Drowned in Maine Lake." May 14, 1928, 1.

———. "Nine of the 10 Men Who Were Drowned in Catastrophe on Moosehead Lake, Maine." May 15, 1928, Extra, 3.

———. "No Negligence in Mishap Says Boat Inspector." May 18, 1928, 6.

———. "Offers Reward to Finders of Bodies." May 26, 1928, 1.

———. "Only One of Party of 11 Saved: Others Drown at Moosehead Lake, Me." May 15, 1928, Extra, 1, 2.

———. "Physicians Pay Tribute to Lake Victims." May 16, 1928, 1.

———. "Plane Goes for Fire Chief's Body." May 17, 1928, Extra, 1.

———. "Public View of Bodies on Saturday and Sunday." May 18, 1928, 1.

———. "Recover Bridgwood's Body." May 16, 1928, 1, 16.

———. "Recover Three More Bodies: Identified as Daley, Dahlborg, Salander." May 17, 1928, Extra, 1.

———. "Report Chief Daley Is Saved from Lake." May 14, 1928, 1.

———. "Rough Waters Force Searchers from Lake." May 24, 1928, 1.

———. "Sandberg Opens Residence to Prince William, Party." January 13, 1927, 1.

———. "Sandberg's Body Floats to Surface." June 9, 1928, 1, 9.

———. "Sandberg Wills $250,000 Estate All to His Widow." June 25, 1928, 1.

———. "Schools in Tribute to Victims of Lake." May 16, 1928, 1.

———. "Search Bills on File Are Itemized." August 9, 1928, 1.

———. "Searchers Determined to Find Lake Victims." May 23, 1928, 1.

———. "Sheriff Blake's, Dr. Peterson's Bodies Located." May 19, 1928, 1.

———. "Sight He Restored, Pays Him Tribute." May 21, 1928, 1.

———. "Silent Tribute to Sheriff Blake by State Women's Club." May 16, 1928, 2.

———. "Simple Rites for Dahlborg." May 21, 1928, second section, 11.

———. "Simple Services for Sheriff Blake Attended by Hundreds." May 22, 1928, 1.

———. "Spare No Expense, Mayors Order to Searching Party." May 15, 1928, Extra, 3.

———. "Speedboat Used to Rush Pictures." May 17, 1928, Extra, 1.

———. "Suggest All Flags Fly at Half Staff." May 15, second section, 1.

———. "Sunken Boat Has Been Located." May 15, 1928, 1.

———. "Table Lake Search Bills as Bettridge Flays Council Opponents." August 7, 1928, second section, 11.

———. "Three Councilmen Fight Moosehead Cost." June 19, 1928, 1, 2.

———. "Unidentified body Is Taken at Moosehead." June 20, 1928, 1.

———. "Use Dynamite to Lift Three Bodies." May 25, 1928, 1.

———. "U.S. to Probe Deaths of Nine in Moosehead." June 1, 1928, 1.

———. "War Veteran Appointed to Medical Post." July 14, 1928, 1.

———. "Widows, Friends Move to Raise Search Funds." August 8, 1928, 1.

———. "Women and Children Wait in Vain in All-Night Vigil." May 15, 1928, 1, 3.

Brockton Fire Department. "Celebrating 100 Years, Squad A: Established 1909." November 11, 2009. http://www.brockton.ma.us/docs/default-source/fire/squad-a---celebrating-100-years.pdf?sfvrsn=4.

———. Concert and Ball Book, 1935. http://www.brockton.ma.us/docs/fire/1935-ball-book.pdf?sfvrsn=2.

———. Moosehead Lake Scrapbook, 1928, 1–57.

Brockton Times. "No Bodies Are Recovered May Employ Navy Divers." May 15, 1928, 1.

Calvert, Mary R. *Dawn Over the Kennebec.* Lewiston, ME: Twin City Printery, 1983.

———. *The Kennebec Wilderness Awakens.* Lewiston, ME: Twin City Printery, 1986.

Carroll, Walter F. *Brockton: From Rural Parish to Urban Center: An Illustrated History.* Northridge, CA: Windsor Publications Inc., 1989.

City of Brockton. Board of Alderman Records, June 4, 1928, page 142.

Commercial Club Brocton, Meeting Minutes. Brockton Historical Society, May 22, 1922.

Daily Boston Globe. "Bodies of Sheriff and Doctor Back." Special Dispatch, May 22, 1928. Accessed via ProQuest.

———. "Brockton on Its Good Behavior." May 28, 1911. Accessed via ProQuest.

———. "Brockton Police Changes." December 22, 1914. Accessed via ProQuest.

———. "Daley New Fire Chief." May 23, 1916. Accessed via ProQuest.

———. "Lays City Marshall." January 13, 1914. Accessed via ProQuest.

———. "No License Practical." October 20, 1909. Accessed via ProQuest.

———. "Voting Today in 14 Cities." December 3, 1912. Accessed via ProQuest.

———. "Will of Dr. Bridgwood, Tragedy Victim, Filed." May 26, 1928. Accessed via ProQuest.

Farrar, Captain Charles A.J. *Farrar's Illustrated Guide Book to Moosehead Lake and Vicinity.* Boston: Lee & Shepherd, 1884.

Harris, Brian. "The New Mount Kineo House at Moosehead Lake." February 29, 2004. http://www.baharris.org/historicpolandspring/MtKineo/MtKineo.htm.

Herderösten, First Evangelical Lutheran Church, Brockton, May 1928.

Hubbard, Lucius L. *Hubbard's Guide to Moosehead Lake and Northern Maine.* Boston: A. Williams and Company, 1882.

———. *Summer Vacations at Moosehead Lake and Vicinity.* Boston: A. Williams and Company, 1880.

———. *Wood and Lakes of Maine.* N.p.: James R. Osgood and Company, 1884.

King, Gilbert. "A Spectacle of Horror—The Burning of the General Slocum." February 21, 2012. Smithsonian.com.

Krohn, William B. *The Courier: History Journal of the Bethel Historical Society.* Bethel, ME: The Society, 2012.

Lowell, James Russell. *A Moosehead Journal.* N.p.: James R. Osgood and Company, 1877.

Maine Fish and Game Magazine (Spring 1967): 2.

Maine Register State Year-Book and Legislative Manual. Portland, ME: Fred L. Tower Companies, 1928.

Maine Town Documents. "Ending March 1, 1928." Paper 2379. University of Maine Research. http://digitalcommons.library.umaine.edu/towndocs/2379.

Merrill, Daphne Winslow. *The Lakes of Maine*, Courier-Gazette, Rockland, ME, 1986.

Municipal Register of the City of Brockton for the Year 1928. N.p.: Standard Modern Printing Company Inc., 1929.

Ninety-First Annual Report of the Municipal Officers of the Town of Greenville for the Year 1928, Greenville (Me). N.p.

Plymouth County Superior Court/Brockton Civil Docket no. 19127. *Carlton B. Howard et al. vs. Harold D. Bent et al.* 1928.

Portland Evening Express. "The Moosehead Tragedy." May 8, 1928.

Portland Press Herald. "Diver's Wife Drives as Bickford Brooks and Helpers Speed to Moosehead Lake to Search for Bodies of Brockton Men." May 17, 1928, 1.

———. "The Moosehead Tragedy." May 24, 1928, 2.

Representative Men and Old Families of Southeastern Massachusetts. Chicago: J.H. Beers & Company, 1912.

BIBLIOGRAPHY

Sullivan, Thomas E. "Enterprise Man Tells Story of Lake Tragedy." *Brockton Daily Enterprise*, May 25, 1928, second section, 15.

Thompson, Elroy S. *History of Plymouth, Norfolk and Barnstable Counties, Massachusetts*. Vol. 3. N.p.: Lews Historical Publications Company Inc., 1928.

Varney, George J. *A Gazetteer of the State of Maine*. Boston: B.B. Russell, 1886.

Wikipedia. "List of Disasters in the United States by Death Toll." https://en.wikipedia.org/wiki/List_of_disasters_in_the_United_States_by_death_toll.

INDEX

ABOUT THE AUTHORS

Coauthor JAMES E. BENSON is the past president of the Brockton Historical Society and Fire Museum and serves as the organization's official city historian. Benson has a BA in history from Muhlenberg College and is currently the parish administrator at Brockton's historic First Lutheran Church. A resident of West Bridgewater, he serves as chairman of that town's historical commission and is an active member of several civic organizations locally and regionally. Benson coauthored *The Swedes of Greater Brockton* in Arcadia Publishing's Images of America series and has authored *West Bridgewater*, *Brockton* and *Brockton Revisited* in the same series, as well as *Along Old Canada Road* and *Brockton* in the Postcard History series published by Arcadia Publishing.

Coauthor NICOLE B. CASPER has worked as the director of archives and special collections and assistant professor at Stonehill College since 2001. She received her BA in history from Stonehill College and MLS from Simmons College. She also serves on the board of trustees at the Brockton Historical Society. She is the author of the Stonehill publications "A Historical Profile of Stonehill College" and "A Look Back: Celebrating the Centennial of Donahue and Alumni Halls." A native of Rhode Island, she currently lives in Attleboro, Massachusetts, with her husband. In addition to her love of history, she enjoys quilting and combined the two in 2008 with the completion of a photo quilt titled "the Brockton 'Shoe Fly' quilt," featuring historical images of the Brockton Shoe Industry, which

was part of the exhibit "The Perfect Fit." organized by the Fuller Craft Museum, Brockton, Massachusetts.

The pair coauthored *The Strand Theatre Fire: The 1941 Brockton Tragedy and the Fallen Thirteen*, published in March 2017.

www.ingramcontent.com/pod-product-compliance
Lightning Source LLC
Chambersburg PA
CBHW070924150426
42812CB00049B/1474